LANDSCAPE PAINTING
IN OIL COLOUR

NIGHT IN THE COTSWOLDS.

THE ART OF

LANDSCAPE PAINTING

IN OIL COLOUR

BY

ALFRED EAST, A.R.A.

Associé Société Nationale des Beaux-Arts, France, etc

WITH ILLUSTRATIONS IN COLOUR
AND BLACK-AND-WHITE

PHILADELPHIA

J. B. LIPPINCOTT COMPANY

1908

N. 12.

E :

DEDICATED TO MY FRIEND

R. H. K.

PREFACE.

IT will be found that I have not attempted in these pages to write at any length on the art of landscape painting in its elementary stages. I have taken it for granted that the reader has, at least, a practical knowledge of the rudiments of drawing, such as may be acquired at any school of art It is, of course, an absolute necessity that such should be the case before any attempt is made to paint from Nature. My aim, therefore, has been to place before the student certain considerations which do not find a place in the curriculum of our art schools, and which should be of assistance to him in the progress of his development

I am of opinion that the cause of a great many of the failures, amongst those who know something of the technique of painting, is their false attitude towards Nature : no matter how closely they may seek to imitate her, their work lacks the vitality which is always associated with that of a master Therefore, while I shall not neglect the necessary hints on the technicalities of art, my chief endeavour will be to point out the best method of employing one's knowledge. However well grounded the student may be in technical ability, he may yet be a complete failure as an artist Beyond the methods of painting there lies the wider problem of the real expression of art.

A boy learns at school the conventional rules of arithmetic, and in after life he probably discovers for himself a system of reckoning which is better suited to his purpose; but had he

not first learned the fundamental rules, his own system could not have been so easily evolved So it is with painting. Technique is of the highest importance. The artist should be able to draw with his brush as easily as a writer uses his pen.

Assuming then that the student is adequately equipped with technical knowledge, my desire is to present to him ideas and suggestions which will lead him to search for the why and wherefore of things which may have hitherto escaped his attention Such thoughts and suggestions will, I trust, gradually widen his outlook, give a larger interest to his work, and endow it with qualities which will mark it as a result of honest personal conviction—an expression of his individuality and character. The striving after such an end as this will increase his enthusiasm for his work, quicken his powers of observation, and help him to look beyond mere super-ficialities All these qualities are necessary to the landscape painter, and in their possession he will find a sure reward. If the student can be induced to study Nature in her broader aspects, and to grasp her higher attributes, which must be present in all art, he will, probably before long, discover the methods by which he can best express what he finds in the world about him There is a curious belief abroad that art is a trick, a species of cleverness, to which anyone may attain by mere practice and perseverance, that success would be assured if one could only secure the confidence of some eminent painter and learn his secret—his peculiar "trick of the trade"

So considerable an amount of unsatisfactory matter has been printed on the subject of landscape painting that it is probable that the student, if he forms any opinion at all, may decide upon a very erroneous one The fact that landscape painting is such a personal expression, and receives such varied treatment at the hands of its exponents, is partly responsible for this error of judgment.

The student, puzzled by so many different methods of expressing Nature, finds considerable difficulty in tracing the underlying principles by which all are governed. For instance, he may look at a Claude or a Poussin, and then at a Turner or a Corot, and find certain principles in the one which appear to be ignored in the other. "I have it on the highest authority," he may reason with himself, "that all these artists are great, but how can that be?" In his ignorance he cannot understand that while Claude and Poussin may be right in their precision, Turner and Corot may also be right in their mysterious generalisation.

I can imagine such a student discovering in a great picture some quality which he takes to be a fundamental principle of art, and in the joy of that discovery he may turn to the work of another master (one of a different school), expecting to find that same quality there But, alas! he seeks in vain The principle, as he thought it to be, is not universal, and in his perplexity he flounders, not knowing where to find a sure basis on which to rest his theories He may examine the method of Turner, which he will find more subtle and elusive than that of Claude He may endeavour to discover how it is that that which looks nothing but a daub at close quarters, grows into life and being when seen from a distance He may make notes, analyse and copy the pictures, and yet remain altogether ignorant of the great qualities the artist has expressed. The problem grows more and more complex, more and more contradictory, and his mind is in confusion. In trying to judge the work of one artist by a standard which he thought had been established by an equally great artist (and therefore trustworthy) he has come to grief.

The masterpieces of musical composition by the exponents of that art are widely different in *motif* and construction, but they are similar in their adherence to the fundamental principles that govern the art of music. So in like manner the varied

B

expressions of landscape art are reconciled in the principles underlying the works of the masters I have mentioned.

There is yet another danger in studying the letter, rather than the spirit of the works of great masters A student having discovered to his own satisfaction their technical methods, and noted all the peculiarities of their work, may at length find himself looking at Nature through their spectacles. It may seem strange, yet nevertheless it is possible, for a man with a mind so biassed and influenced to approach Nature and see anything in her that he is predisposed to. If he looks for the leaves of a tree carefully arranged in the style of the old masters, he can see them ; he may even go so far as to discover their repetition, and the peculiarly affected contours of the branches against the sky In short, he may become a slave, and sacrifice his own powers of direct perception to his faith in these formalisms. Eventually he will see Nature entirely through other eyes than his own

But there is one point upon which I would insist—that is, that the conception of the truth and beauty of Nature is not the exclusive possession of one painter, however great he may be. Nature is too boundless in her variations for all her truth to be grasped by one mind. There are aspects that are revealed by Poussin and Claude, and others which elude them, but which Turner and Corot turned to such glorious account. These painters took from Nature just exactly what they wanted for the due expression of their feeling in art. And Nature has some message, some charm, some revelation for each individual, if he has but the eye to see and the hand to record it Believe me, whatever fault one may find in a work of art, the blame cannot lie with Nature. The greatest errors in landscape painting are to be found—contradictory as it may appear—not so much in the matter of technique as in the painter's attitude towards Nature. If he be a realist, Nature spreads out before him the most wonderful objects, whose beauty

is revealed by their faithful delineation. If he be a romanticist, she furnishes again just the special qualities that appeal primarily to his heart. So I would point out to the student the manner in which to study Nature; how to look for what he wants, and at the same time impress upon him the responsibility that lies in the selection of material As I said before, Nature is so bountiful that the poverty of a man's work can never be due to lack of material, but is rather owing to his incapacity to select judiciously from her generous offering.

While acknowledging our debt to the past, no true artist will be content to rely unquestionably upon previous authorities, nor allow himself to be unduly biassed in his judgment by the influence of their works, however fine No, it is for every man to work out his own salvation in art, and to be prepared to accept the full responsibility for his work. He must tread his path in a spirit of fearlessness and confidence, yet with humility, assured that Nature is for him and his particular use. Problems there are still to be solved, and he must solve them for himself in accordance with his own ideas.

To imitate and to copy is the resort only of the small-minded man. He may not be fully conscious of his servile attitude towards those he holds in high respect, but his lack of creative power is an evidence of the overbearing influence their work has upon him The student's aim should be to emulate the great masters in the *spirit* of their work, to strive after their independence of outlook, and their high standard of craftsmanship If Nature itself does not suggest to him those higher qualities that are always present in a great work, then the student may rest assured that his vocation in life is not that of a landscape painter.

There is no royal road in art. In this department of life, as in every other, the student must serve before he can govern He must learn to construct, to draw, to paint, to observe, and select

And it is only by close application and increasing perseverance that he can achieve anything worthy The stamp of personal purpose must manifest itself in order to make his art distinctive— a purpose that raises his work above that of his fellows in spite of the similar course of training through which they have passed.

My object, then, in the following pages, is to help the student to see with his own eyes the things that are essential to his purpose. Nature has so much to offer that her very generosity may prove a snare, since there is a danger of wasting time and labour in the selection of non-essentials, for that which does not help is a positive hindrance. My knowledge of the difficulties that beset the path of landscape painters may enable me to be of some service But of this I am certain, that to those who with patience, with minds free from bias and prejudice, determine to become masters, to them will come the pleasure and the ability of expressing their love of Nature in a language that is perhaps the most beautiful mode of human expression—that of landscape painting.

CONTENTS.

———◆◆◆———

CONTENTS.

CHAPTER VIII.

CHAPTER IX

CHAPTER X.

CHAPTER XI.

CHAPTER XII

CHAPTER XIII

LIST OF ILLUSTRATIONS.

COLOUR

HALF-TONE

PENCIL SKETCHES, &c

MISTY MOONRISE.

FROM THE PAINTING BY ALFRED EAST, A.R.A.

LANDSCAPE PAINTING IN OIL COLOUR.

CHAPTER I.

ATTITUDE TOWARDS NATURE

YOUR attitude towards Nature should be respectful, but at the same time confident. One should love her without giving up one's authority Do not grovel before Nature—be a man. Stand to your work, and draw and paint from your shoulder in a confident and manly fashion, feeling that you know what you want, and go for it fearlessly, with a keen observation of Nature. Look long at her, consider carefully, and then, when you have made up your mind, express it confidently and in a manly fashion Do not go to your work as a task, but as a labour of love One can detect at once the work the painter attempts with an immature knowledge of Nature, it is not confident and spontaneous, and if he gets, after great labour, something approaching what he wanted, the evidence of his fatigue is apparent There is no fatigue in Nature. She expresses life with a curious and interesting sense of directness. Although we know there are millions of years behind her simplest developments, yet the result is one of apparent ease, a spontaneous and direct effort. So should your Art be, and it is in this respect it should resemble Nature, revealing an infinitely higher quality than the mere imitation of her surface.

c

Paint as if you had the authority of a man, as though all Nature was made for your use, to be at your disposal. Respect the power which lies behind Nature, and if you respect that, it should keep you from the abuse of her, and should bring you into closer touch with the great purpose of her being

Build up your picture from the broad masses; don't finish your trees, or your sky, or your distance first Work on them all at the same time, keeping them in tone like an orchestra. Keep them all in hand like a musical conductor Have no false notes, no discordant line or colour

Keep in your mind that you must not be ruled or unduly governed by what you see in Art, but by what you see in Nature. Don't form altogether your ideas of Art from pictures, but from Nature That is your business. The value of tradition in Art is a question we will not discuss here. It is sufficient for one to get into touch with Nature and be in the most intimate sympathy with her. Take every means in your power of learning more of her, and her methods of work, and her possibilities of expression Learn all about her, what she will do under any and every effect You will not succeed in finding out all the possibilities of her expression of beauty in her many moods, but you will, in the course of time, know a great deal that will be helpful For instance, in taking the trouble to paint a sky every morning, at the same hour, for a few weeks, no matter what the sky is, at the end of the time you have learned something more of the sky than you can read in the latest scientific book; and so of other things

I find that if I draw a tree every day for a month, I have gained some knowledge of the peculiar characteristics of trees that had escaped my observation before. It is of no use knowing the names of the bones and muscles of the body unless you know what they will do in action. One ought to know a tree so well that one can alter its form to suit the purpose of one's

composition without the slightest loss of its characteristics, just as a figure painter should know anatomy so well that he can put his figure in action without a model, with as much ease as he could draw it in repose. This knowledge gives one confidence and authority, or, shall I call it, faith in oneself? If you desire to transpose your trees, for instance, to put in some that are growing outside the area you have selected to paint, if you feel that such are necessary for the composition of your picture, you have as much right to put them there as the yokel who planted them where they are growing some fifty years before. But you have not the right to do so if you do not know sufficient of their characteristics; you will be found out, for they will look as if they were artificially put in But if you know them well enough, their requirements of soil and situation, as well as their construction and character, they will be right My point is—get knowledge Find out the why and the wherefore of all things. The greater your knowledge of Nature, the simpler and stronger will be your work.

You may take up the interesting study of reflections or the study of the colour of shadows You may note the form of shadows, the differences of their forms in proportion to the distance from the objects on which they are thrown; you may see that in one case the interstices of the trees are rounded like a photograph out of focus; at another time they are sharp, like a Japanese stencil, clearly cut, and of a beautiful pattern You may note the interesting difference of colour of the landscape during the progress of the day You may note a thousand valuable facts There is no harm in studying the reflections in a dewdrop They are very wonderful and beautiful, but don't do it till you learn more of the earth and sky The little bits of Nature are very interesting, but your business is to do with big things, to grasp with a strong hand the great essentials for your work

You are to build up your landscape with the best of the beautiful materials you can find, and not to be led aside from your purpose by the little things that are not wanted, even if they are beautiful. Go forward in the world with a purpose, a great purpose You are responsible for the work you do, and you only The material is right, Nature is as kind to you as she was to Shakespeare. If there is a fault or failure, do not be so mean as to suggest that it was due to Nature Shakespeare does not tell you what buttons were on the coat of Hamlet, but he *does* reveal to you the secret of his character. We do not want the buttons and the braid and all the stage properties; we want the living, sentient man, his place in life which makes history And so with you You do not want the pretty little things of Nature, you want the big strong essentials which stir the heart of man, and show that you have felt and seen them and can reveal them to others. Strong men are working in other fields of thought for you, and they look to you for your part to be done well, as you expect the best from them

The architect may build from the same quarry that supplied material for St Paul's, and yet the building may be beneath contempt So you must know that there is no excuse for you. Nature is for you, as it was for all men And if you know it as well as the great who have gone, you will be able to tell us something new, as they did, even if it be different.

Again, let me impress upon you to approach your work in a manly, confident spirit Be not ashamed to do the drudgery of constant practice at drawing or sketching Learn to serve and keep awake. Have your eyes and your heart open, always working Keep your picture together, a touch here, a touch there, whatever you can correct, do so—here a touch in the sky, there one in the foreground, another in the middle distance Build up your entire picture as one great whole, one intention; not in patches of separate interests, but all tending to one purpose and

one only, every part being interdependent upon another, that the whole should be sure and certain, as confident as a sketch, and as spontaneous as Nature. There should be no sense of fatigue, it should appear as if it were simply and easily done You may have sweated at it, you may have given it weeks of thought, both by day and night; you may have groaned and writhed in the deepest anxiety, yet the result should be as simple and direct as a beautiful sonnet · that shows your conquest No more, no less is wanted. You have secured what you wanted, and it is finished

If you have no enthusiasm, and lack courage, stay at home and do other work that befits your temperament A landscape painter must have enthusiasm, and no shame in speaking of the pleasure he feels in his work I think it is useful to speak about what interests you most; but be quite sure that you have the sympathy of the person to whom you speak You need not be ashamed of your calling, for if you knew the innermost feelings of the hearts of others, you might find that you are envied by those who cannot purchase the pleasure you have in following the calling you love best in life

CHAPTER II

EQUIPMENT.

IN the selection of your equipment you must bear in mind that comfort and usefulness are of the greatest importance. The art is difficult enough without the additional drawbacks incurred by bad materials and inconvenient camp-stools and easels. A camp-stool that is uncomfortable, and that causes one to sit in a cramped position, or occasions a constant and distracting sense of its insecurity, is an unnecessary evil; and one should also avoid an easel that requires a great deal of fixing, and arouses nervousness at every puff of wind. Nothing whatever in your apparatus should withdraw your mind from your work, your whole attention is demanded in the production of a successful sketch. What can be more annoying, when one is striving to take full advantage of a passing effect, say of a distant rain cloud on a mountain side, if at the very moment a sudden squall overturns your easel owing to its bad construction, and you find your sketch face downwards on the ground? An easel for out-door sketching should combine the qualities of lightness and stability. If both cannot be secured, then by all means sacrifice the lightness, not the stability.

For many years I have used a rack easel, revolving on a ball-and-socket joint, and stiffened at the desired angle by a thumb-screw. The legs are telescopic and can be shortened or lengthened to suit any irregularity of ground, and can be opened at so wide an angle as to render a sudden overturn by the breeze impossible. The rack can be so arranged that your picture can stand perfectly

LAKE BOURGET, FROM MONT REVARD.

FROM THE PAINTING BY ALFRED EAST, A.R.A.

upright and firm—a very great advantage when painting in oil, as the reflection of the sky on the wet paint always creates a difficulty. As an easel for water-colour work also it is admirable A rack moving on a ball-and-socket joint can be pulled over into a horizontal position, which enables the colour to dry flat, and prevents it running down, as often happens when the ordinary upright position is maintained. The only fault possessed by this easel is that, in spite of its light weight, it is somewhat unportable. This, however, is only an objection when you are packing your things for a journey, and it can be overcome by taking the easel to pieces, and as the parts are fastened by brass thumbscrews, the process need not be a labour. I have taken such an easel to many countries, and used it under all conditions, and found it excellent. Of course, it will not hold a larger canvas than the extent of the rack, unless you take the trouble to put two large screw-eyes into your canvas-strainer which will grip the rack behind.

This device can be dispensed with if you are provided with a " Hook " easel, which, for large canvases cannot be excelled. This easel is so well known that it is scarcely worth while for me to describe it As, however, this book may fall into the hands of someone who has not seen or used the apparatus, a few words of explanation will not be out of place. Briefly described, it consists of three poles of seven feet long and about $1\frac{1}{2}$ inches in diameter, and five screw-eyes large enough to admit the poles These screw-eyes are screwed into the back of the canvas-stretcher, and so form of themselves an easel. A small thumb-screw fixes the screw-eye on the poles at the elevation required One screw-eye is hinged for the back pole The advantage of this easel is, that it will firmly support any sized canvas up to six feet or more, and, by the addition of another ring and pole, it may be made to resist half a gale of wind, while a guy rope from the back pole screwed into the earth prevents it being blown over from behind. You can raise or lower

the picture at will, and it can be placed at any angle on irregular ground.

I have spoken of the necessity of comfort in painting, and you may be assured that an easy seat is of the highest importance for both health and work How many students complain of indigestion, caused by the cramping of the stomach resulting from the use of a low stool! It should be as high as an ordinary chair, or at least as high as any seat you usually feel at ease in. To my mind, nothing is better than the tripod with a strong ox-hide top, which, while you are out in the country, can be temporarily fixed by a tack to the stool underneath. This plan prevents loss of time and trouble in adjusting the seat every time it is used

Now as to the canvas upon which you are to paint your picture There are many opinions as to which is the most suit-able, most of them formed by artists who get into the habit of using one kind For instance, some prefer a coarse canvas, and others choose a very fine texture I think the best is a medium grain, which will not show disagreeably the texture of the linen when painted, and which is not too absorbent. It is better white, since it is quite an easy matter to give it a wash with spirits of turpentine in which a little burnt sienna is mixed to tone it to a softer tint The turpentine also gives the surface a pleasanter "tooth," or surface to work upon, and takes away the oily and shiny appearance. Some prefer a half-primed canvas, that is, one with less preparation upon it This is very agreeable, but it requires a richer body of paint than the more fully primed, and there is less danger of subsequent cracking I have used many kinds, but the most agreeable is that which I have prepared myself, more or less after the manner of the old masters, and it may be worth while to supply a brief description of the process

First you strain the best linen sail-cloth of moderately fine

texture over your strainer, then give it two coats of thin size It is advisable afterwards to sterilise the size with a wash of a solution of formalin This prevents the formation of fungi by the action of the atmosphere on the size, and so prevents the eventual scaling of the paint. The ground preparation which I use is the finest china clay, thoroughly dried in an oven, and the best white lead, mixed with bleached linseed oil and spirits of turpentine, and a little copal varnish. If you want an absorbent surface, add a spoonful or two of water. The first coat is applied when the size is thoroughly dry and smooth. A second is overlaid in the same manner, care being taken to leave no coarse brush marks. It should not be painted on for at least six months afterwards. The canvas, treated as I have described, may be put on one side and exposed to the light as far as possible, as darkness always tends to discolour white lead. I believe canvas so prepared is more reliable than any other, and it will support the colour without cracking, as happens with preparations of inferior quality.

Now we come to the paint box. This should be made of wood, thoroughly seasoned, since it has to bear the changes of temperature and moisture. When at work in the morning, if one places the box on the dewy grass, the bottom gets wet and the lid dry, and the shrinkage will prevent its properly closing. In the evening these conditions are reversed ; hence the necessity for well-seasoned wood. The ordinary boxes (originally made in France, but now obtainable at any art-colourman's) are best. About 15 inches by 12 inches is a good size It is an advantage if the box has a brass knob on each side to which you can fix a broad strap so as to carry it from the shoulder. It should contain palette, colours, medium, turpentine, and, if space permits, brushes , though, if you have not room, you can, of course, take a separate brush case. And be sure you do not forget your charcoal and pencil

D

The medium and turpentine should be in square tin bottles with screw tops, and should fit snugly in their allotted places The box should contain colour tubes in proportion to your needs. For instance, the largest will be white and the rest will vary according to the demands likely to be made upon them. I mention this, because weight is a consideration when one has to carry one's own material, and it often happens that your subjects are a considerable distance from your headquarters, so that you should take only the minimum weight

The colours constituting my palette, together with the sizes of the tubes usually taken in the box, are as follows .—

Flake white *	½ lb tube.	Venetian red ...	Small tube	
Yellow ochre	¼ lb „	Raw umber	Medium „	
Pale cadmium	Small „ †	Cobalt	„	„
Mid „	„ „	French blue	„	,
Deep ,	„ „	Veridian	„	„
Rose madder	, „	Ivory black . .	„	„
Burnt sienna	„ „			

Vermilion can replace rose madder if desired.

These should go into your box comfortably. The palette fits over them, and there is space for the dipper, which should be large enough to receive your largest brushes. The box is generally made to hold several wood panels, which slip into the groove in the lid These are useful either for a study of the picture you are painting, or, if the effect you desire is not visible at the time, you can do a sketch while you are waiting till it comes on I have found these wood panels the greatest solace. When you start out in the morning to a subject which may be miles away from head-quarters, the day may promise the sunny effect you desire ; but just after you have arrived, fixed the easel, made sure of its stability, and added the security of the guy rope, the sun may

* If it is found that the lead fumes arising from the flake white are disagreeable and injurious the new flake white prepared by Messrs Madderston & Co , which is harmless, might be used

† The small tubes are suggested to save weight , for studio work the larger sizes are better

abruptly conceal itself behind a block of clouds which seems to extend as far back as the eye can reach, and all your preparations appear to be wasted One experienced in such matters knows how annoying this is Unfortunately it is far too common an experience in our uncertain climate, and it is the more vexatious if you have walked some distance to paint a particular shadow across a road, or to correct your colour values by reference to the original conditions under which you started your landscape. This is a crisis where the pencils and panels come in so happily Instead of tramping back in an evil temper, you can spend the morning in making a study, or doing a sketch under the grey sky which has postponed your larger enterprise

The morning, after all, has not been thrown away. The panel is slipped into the groove of the lid of the box, and one has the satisfaction of feeling nothing has been lost by the change of weather, which at first looked like a disaster.

It is difficult to give advice in the matter of brushes Every artist has his own peculiar idea as to their make and shape. Some prefer a round full brush, others a thin flat one , some again like round thin ones, and others just the opposite. No doubt the pattern of brush must depend mainly upon the nature and method of the work In the case of those who paint from a generous palette, it is necessary to select brushes that will hold a larger quantity of colour. One's choice must also depend upon whether one uses the colour direct from the tubes without dilution, or whether a greater quantity of oil or other fluid medium is employed I remember this problem weighing upon the mind of a distinguished lady, who was buying her colours with all the diffi- culties of tree painting confronting her. She inquired if the shop- keeper had any " tree brushes " ! The man was equal to the occasion, for, bringing round some brushes, he assured her they were exactly the same as "So-and-so" (mentioning an eminent painter) used in

painting landscapes I beg of you not to get any fads into your head as to any easy or special method of arriving at certain results. There is but one method It is the familiar and only effective one, namely, that of study and hard work The achievement is not reached by the style of the brush, but through the training of hand, eye and brain.

But though you may not ask for "tree brushes," yet you would naturally like to know how trees are painted "They are such tiresome and difficult things to paint," I can fancy you saying Well, they are But later I will give you a few hints which may help you. Meanwhile we must have all our materials in order before setting out to work, and not the least important items are the quality and size of your brushes Let them be of the best, for these are the cheapest in the end I use a full hog hair brush, of a size from 1 to 8, and one or two small sables, sizes 0 to 2 A few long-haired sables may be convenient for drawing the branches of trees. Two each of these sables, and three or four each of the medium-sized long hair, and one or two larger ones, will be sufficient At the end of the day's work always wash your brushes, either in turpentine or with soap and warm water, or put them in a vessel containing paraffin oil.

Now I have provided you with camp-stool, easel, a box containing colours, medium, spirits of turpentine and brushes By the way, I should advise you to use oil copal medium. It is safe and dries well * Do not forget to take a piece of painting rag , you will find butter muslin, costing about 3d per yard, excellent for both water colours and oils, and it is effective for wiping off colour, if necessary.

To sum up with a few practical hints .

Put your things right the night before starting.

* Quick drying poppy oil is excellent, or a medium made of equal parts of spirits of turpentine, linseed oil, and amber or copal varnish is good

Don't be in a hurry lest you forget something that is necessary
Be provided for an emergency, such as a change of effect.

Don't be too respectful to Nature at the beginning, but very much so when finishing

Open your heart and eyes widely Don't be perverse. Approach Nature with the heart of a child

Don't *try* to be sincere, but be so, and be strong.

CHAPTER III.

SKETCHING FROM NATURE.

DON'T take any makeshifts out when you go sketching The less you know how to use your tools the better those tools should be It is only good workmen who can use bad tools to any purpose, and they choose not to do so. It is the truest economy to use the best materials.* It is also a mistake to think that simply because you are going to sketch, you need not take much with you The real enjoyment as well as the success of your sketches will to a large extent depend on your forethought in this respect It may be you have walked several miles to sketch a particular subject you had probably seen under a certain effect the day before, when you had no sketching material with you Full of pleasurable anticipation you start away, thinking how you will treat the subject , whether as an upright or an oblong, whether the shadow would be better if longer, or shorter, or if the distance should be in sunlight or otherwise, and many other considerations which go to make up your anticipated enjoyment The air is fresh, the clouds sail past in great columns, and at the turn of the road you see your subject ! You arrive, your camp-stool is fixed, your easel arranged and your palette prepared. You carefully draw the outline of your subject, and you feel that the scene is even more beautiful than it appeared the day before when you discovered it Your pencil outline is done, and you open your box. Alas! your brushes? You have left them at

* You can, of course have your sketch-books and canvas of inferior quality, but for work which you hope will last it is absolutely necessary to have the best

MIDLAND MEADOWS.

FROM THE PAINTING BY ALFRED EAST, A.R.A.

home! Then one has no proper words adequately to express the situation. there is no rustic available to fetch them, even if you quite knew where you had left them, so there is no alternative but to tramp back. With what different feelings you trudge your way along the road which now seems so tedious and uninteresting! If you are a wise man, you will at once get a bag and see that all the things required are in it before you start You may find it necessary to have big brushes when you have only brought small ones, and *vice versâ*, thus your pleasure as well as your work is spoiled Be prepared for every emergency. Things which seemed improbable sometimes happen.

Another reason is, that in making a sketch from Nature, your full powers must be put forth. You must be strung up to a high pitch Every sense must be on the alert, for if you are not keen and quick you may miss everything You may miss the particular effect upon which the whole charm of your subject depends, for each sketch should be done at a single sitting.

It may be you have for your subject the sweet meadow-land of the Midlands of England, across which the shadows of the sailing clouds steal over the cut grass, lighting and re-lighting the distance, the middle distance and the wood, at the edge of which nestles a little village There is nothing amiss with the subject It expresses the peculiar characteristics of our country. Beautiful as it is in itself, how much lovelier does it seem when seen under the special conditions for which you have patiently waited! Never mind if you have to get out of bed at dawn, it may be worth the effort; or if you have lingered until the white mists have stolen along the flats, and your dinner has got cold, it is worth the sacrifice. For, remember this important fact, you cannot get a dawn or a sunset repeated In a long experience of careful observation I have never seen two dawns or two sunsets alike. Unlike history, they never repeat themselves When you have

satisfied yourself under what conditions your subject looks best ; when you have risen early, morning after morning, or stayed out till dusk, evening after evening ; when you are certain that the very best conditions are before you, then make a start with that courage and confidence without which nothing great is ever achieved Courage, confidence and alertness are supreme qualities in sketching from Nature There are many things to be borne in mind which you must keep constantly before you The progress of the shadows on the hills, which give such a wide foil to your sunlit trees, will not wait for you, and if you glance but for an instant you will see that the sky is clearing to windward, and you may have no more cloud shadows that day

When you start, you must allow for the whiteness of your canvas, which by strong contrast may make your work appear too dark. Allow a little, too, for the drying in of your colours. The exact tone of the hillside is more easily obtained, since its effect is more continuous Then place below it the trees in the exact colour and tone in relation to the sunlight and shadow of the hills Afterwards note the grass which is of a more local green, and paint its exact pitch in relation to the preceding tones. The road has its shadows across it Note the subtle quality within the shadow that suggests the material of the road, for the road material should be recognised as the same under all conditions of light and shade. For instance, a shadow across it must not be like a piece of dark cloth laid down, but a luminous tone full of the reflection of the sky Observe that the edges are darker and colder than the general colour of the shadow. You may ask, "Why not paint the sky first ?" I know you have been told to do so, and as every painter has a reason for what he does, let me explain why I should not. It is much easier to paint a sky to suit a landscape than a landscape to suit a sky. The frequent cause of so many pictures showing a divided purpose in this

respect arises from the unsuitability of the landscape to the sky or *vice versâ* You want the sky to belong to the landscape as much as its trees or its fields, and as the cloud forms greatly depend upon the existing contours of your composition, they can only be put in after these contours have been arranged.

Your business in sketching from Nature is to give one a fervid impression of the place, its biggest facts painted in just relation to each other, and its characteristics set down frankly, fearlessly and in the most direct manner possible. In So far as your sketch endorses the above qualities, it will be good. The moment you begin to hesitate, the moment you begin to neglect the larger facts, you will get wrong with your values, you will lose the sense of spontaneity which is the charm of your sketch There is, I know, always the temptation to realise the beautiful details of Nature, but you can make a careful study of them at your leisure, for you must never sacrifice the big things of your landscape to the details of your sketch.

The exact harmony of sky and land, of trees and pasture, of light and shade, of colour and tone, these are the essentials which you must strive to realise, and these are sufficient, in all conscience, for you to keep in hand without the consideration of the particular forms which make up your foreground and masses And you will find that your masses will be more correct, if treated in this way, than if they were niggled to the loss of their general breadth A sketch may be described as a study, but a study never as a sketch The sketch deals with the big things, the passing effect of sun and shadow, of storm or rain, of dawn or sunset, and must realise the sense of each particular and peculiar set of conditions pertaining to the various effects But a study is a faithful drawing or painting of a particular portion of the details which may be useful to you in painting a serious picture, and I shall later describe how both may be brought into one's service for that particular purpose

r.

Now if you have succeeded in obtaining a sketch which fixes fairly and truthfully the facts of a passing and changing effect, you have done well. You have had to attend to many things, you have worked under great pressure of thought, you have had many irons in the fire, and, if you have succeeded in keeping them all hot, every part of your sketch should be equally fervid and spontaneous. Having realised the object of your sketch, you might then, as a relaxation, turn to some of the details, and, on a separate piece of canvas, make a very careful study of them, otherwise you would not know them sufficiently to use them in your picture I have endeavoured to point out to you the characteristics of a sketch and a study, and I would like to show you how you should proceed in a practical manner when sketching from Nature, or in making a study

In addition to their intrinsic interest, sketches reveal the character of the artist even more clearly than his finished pictures They are, or should be, the vivid expression of his appreciation of Nature under a special emotional impulse, and on that account are worthy of preservation. I think more is to be learned from the sketches of a great artist like Turner than from his more elaborated works, where much of his psychological attitude is disguised. I should strongly advise you to study those in the National Gallery.

It is better to sketch rapidly, since it is difficult to give the time necessary to the delineation of form under the conditions of changing light. Bear in mind that if we start in the morning, we have the shadows from left to right, and in the evening from right to left, and through the intervening hours the shadows are continually modifying the contours of the landscape. We cannot command the sun to stand still, or arrest the rain cloud, so we must make the best of our limitations Since it is so difficult to observe the subtler aspects of Nature in the fervent heat of sketching, it is necessary to analyse them, and study them separately.

GIBRALTAR, FROM ALGECIRAS.

FROM THE PAINTING BY ALFRED EAST, A.R.A.
IN THE WALKER ART GALLERY, LIVERPOOL.

It is not only a profitable, but a very pleasant pursuit to make pencil drawings of the component parts of the subject one is engaged upon, and thus accumulate a mass of material for the picture of a larger scale In sketching from Nature, do not seek to make incomplete pictures. An unfinished picture is not a sketch, nor has it any value except as practice.

In landscape painting there are three stages—the sketch, which aims chiefly at command of colour; the study, which devotes itself to the truth of form; and finally, the picture, which unites the fresh impressions of the sketch, with the more systematic comprehension of form which is the object of the study. The picture is the end, the others are the means; and the end cannot be attained, in the best sense, unless you cultivate the discipline of the means. Of course I do not for one moment suggest that a colour sketch should be devoid of accurate form, but it is necessary, in order to fulfil its purpose as reference in subsequent work, that it should be, above all, true in its chromatic values, even if false in its form. The form is always with you, whereas colour is transitory. If it be possible to secure both at once—good; but I think you are hardly likely to achieve the complexities of colour while your attention is engaged, at the critical moment of the effect, on the exactness of form. The general outline may be recorded, but when one is absorbed in the contemplation of colour in Nature, the element of form is perforce very much subordinated

Landscape painting is the realisation of inspired conceptions Some artists are moved by minute details of Nature, others by the wider and bigger attributes. To those who love her, Nature is always responsive. She offers everything you ask. You want the dust and cinders that make up mountains— they are there; or you want the clouds which mingle with the everlasting fires—they also are there. You may choose the rubble and dirt, or you may choose the peaks which keep proud

company with the heavens. If the painter wishes, he may paint every blade of grass He enjoys perfect freedom , no law forbids But he should not particularise his blades of grass in a broad meadow, nor specify the grains of corn in the wide sweep of the harvest field. We know the meadow is covered with tiny blades, but we do not see them individually , we see only the aggregate of their form and colour, and a broad general suggestion is as faithful to Nature as would be a multitude of petty details which we do not see in an ordinary outlook. The suggestion of the fact that the tree is thick with leaves, and that it is living and moving, is infinitely more satisfying to one's sense of truth than would be an immense and painful mass of innumerable and carefully realised leaf-units. The goal to strive towards is the living impression of a tree as a whole—as a being, so to speak—and not of a colossal repository of detail The advice I give you is to draw as well as to sketch from Nature every day ; and slowly, but surely, you will feel yourself competent enough to start a large canvas, and you will be able (so to speak) to see your picture painted, before you touch a brush.

Draw the landscape as simply as possible with charcoal, afterwards going over the lines with pencil ; then dust off the charcoal, and you have the drawing left by your pencil. With the confidence which comes after considerable practice, you will be able to dispense with the charcoal and pencil, and start at once with colour. Your paints must be so arranged on your palette that the colour most frequently used is the handiest, viz white, and then follow the yellows, reds, blues and greens. It is necessary to have a system in placing your pigments on your palette, as it saves time, and time is of the utmost value when you are rapidly sketching a passing effect The crucial effect so soon fades, and one's memory loses its acumen so quickly that you must not trust to it , therefore you cannot afford to lose time by wandering round your palette

MORNING MOON.

FROM THE PAINTING BY ALFRED EAST, A.R.A.

for a certain colour. The place of each colour should be known to you as intimately as any note on the keyboard of the piano is to the musician. Use plenty of paint, but not too thin. Do not miss solidity through thinness of colour. A little medium, composed of equal proportions of copal or amber varnish, turpentine and linseed oil, is helpful. With a brush which holds an ample supply of colour, lay it on your canvas frankly and fearlessly, always remembering that, within reasonable limits, you can, later on, correct mistakes.

The sky can be painted first with a coat of white, tempered with yellow ochre, and the blue patches of the sky painted into it * Exact tone and colour are as important in sunlit areas as in the space shadowed by the cloud It is essential to ascertain the difference between the sunshine and the shadow. Having settled what you feel to be the exact difference, place the colours down upon your canvas. But if you are not quite sure of the result, wait for another shadow to correct your values. Utilise your cloud shadows for form as well as for colour ; the shadow displays the varied contours of the ground over which it falls, and thus affords a valuable aid to perspective Perhaps the shadow may cross the wood on the hillside, and leave the church and cottages in sunshine You will quickly detect the difference between the trees in shadow and those in light. Fields which were vivid in their rich green in sunshine, become more subdued in shadow, though not less luminous. The foreground grass, for which you might have used bright cadmium and transparent oxide of chromium, must now be represented in a combination of yellow ochre and cobalt, or deep cadmium and French blue

Bear in mind that, although the colour of the middle distance and extreme distance may be lowered, it must convey (as in Nature) the impression that it is composed of exactly the same

* See chapter on " Skies " (p 64).

materials ; that is to say, the distant grass must look like grass as distinctly as that in the foreground. There must be no halting to inquire, no hesitation in this assurance. The diminished size of trees, houses, and other familiar objects explain their own distance ; but large spaces, as for instance of grass fields on a hillside, depend more upon aerial perspective, the criterion of judgment being in this case a just tone of colour rather than the diminution of individual objects.

I have no doubt that you will find the middle-distance objects extremely difficult to paint, and I fear many artists use the same colours as in the foreground, merely diluting them by the addition of white, thinking they will thus secure the desired alteration of tone This is not the case. All the various distances, which we describe as middle or remote, not only demand a change of actual pigments, but a fresh combination of colour. Thus, while the foreground may consist of the strongest greens, the middle distance may require white, yellow ochre and blue, and in the far distance, rose madder, white, a little yellow ochre or raw umber. Now I would ask you in oil painting not to dilute your colour with oil or medium more than is absolutely necessary for facility in working This is a fatal error made by so many amateurs when painting from Nature. You must learn to master the somewhat stubborn material, and when you have overcome the technical difficulties of the craft, you will find the great advantage of being able to manipulate a fuller body of paint

When you have painted the foreground, the mid-distance, the wood, the light on the church, the village, you have practically completed the sketch with the exception of the sky, and that should harmonise with the structure of the landscape as a whole. The forms of the clouds must preserve a suitable relation and sympathy with your landscape Their contours must assist the lines of your composition, and their character be in keeping with the effect you

have elected to paint.* Their scale also must be studied, for it must not lessen the sense of the width of the meadow or the near distance, or the distance of the hills. Now you have the opportunity of perfecting your composition. You may put in that little bit of extreme distance which so beautifully melts into your sky, and you will consider whether the pool in the foreground should reflect the white or the grey-blue of the heavens Do not hurry your sketch now, for the effect you sought after has passed; you cannot improve on the first vivid impression, and though the forms still confront you, you cannot invent the exact relations of colour which Nature only has the privilege of creating. Leave well alone; or, if you are not pleased with the day's work, repeat the subject to-morrow if the weather is the same, and the experience you have gained will guide and nerve you for your next attempt.

* See chapter on " Painting from Nature" (p 93)

CHAPTER IV.

PENCIL DRAWING FROM NATURE.

BEFORE touching a brush, one should make a series of pencil drawings of the subject one afterwards intends to paint. The landscape painter may, after spending many days on a picture, despairingly conclude that the composition is hopeless The disappointment might have been avoided had he curbed his impatience, and executed a series of preparatory drawings for the composition in his sketch-book.

For this purpose I would recommend a large linen-covered book (15 inches by 12 inches is a good size) and a thick lead pencil. I use a pencil with a loose lead, one-eighth of an inch thick, which can be screwed up in the holder when required. Do not attempt to sharpen it to a point If you wish to get a thin line, use the edge of the lead; but you will seldom need such a line. Touch lightly, and in the faintest possible manner, the salient features of the subject, the main contours and the position of the masses This should be the merest suggestion of an outline, and when you are satisfied, draw it in with courage, in big lines, with a firm, bold touch. Do not hesitate Include only those things which are important, characteristic and essential. After some experience you will not stop to think what these things are, for they will come to you by intuition. If you have any doubts, draw all that comes within your view. By practice you will be able to make a drawing in a few minutes which spontaneously indicates the principal parts of your proposed picture. You can carry it a step beyond the mere outline, if you like, and add the shading of the broader

24

masses, for you may discover that in pencil-work, as in painting, light and shade influence the quality of form. A week or two will do wonders if you practise daily Have your sketch-book with you at all times—not only when you have a specific object in view, such as that already referred to, but ready for any opportunity that occurs It should be your constant companion It is more useful than your colour-box, in the sense that it is more convenient. You can take a note of an interesting cloud formation, the peculiar shape of trees, or some bit of useful fore-ground, or of the movement of a figure Draw anything, every-thing. You may do it badly at first. Never mind In a week or two you will be surprised at the progress you have made You will by that time have learned more than you ever knew by previous theorising, and you will begin to look for better qualities of drawing than you did before. You will construct

FIRST SKETCH FOR "THE AVENUE"

F

SECOND SKETCH FOR "THE AVENUE"

THIRD SKETCH FOR "THE AVENUE"

THE AVENUE.

things better; you will also observe the difference in the growth of the various species of trees, and if you are drawing a cow, you will see that the shoulder is just so far from the head, you will note the correct set of the horns, the peculiar formation of the jaw, everything in fact will have a new interest for you.

Your sketch-book should be the receptacle for designs of landscapes, and when by means of these drawings you have accumulated the best material and have obtained a satisfactory result, you can then begin your picture with confidence

You will see in the accompanying illustrations from my sketch-book three trials for a composition, each of the same spot, but all different In the first sketch I have placed the trees as they were in Nature, in the second I have made an alteration in the distance, and the third is the final composition which I afterwards painted but *reversed* I recommend you frequently to practise the drawing of trees Take, for example, the ash, which is not so difficult as many others; then proceed to the oak, willow, elm and poplar Draw in the landscape, so as to get an idea of the composition, and when you are competent, re-arrange the material before you to suit the purpose you have in view.

Never let anything prevent your drawing a little every day Draw the intricate hedgerow, or the big cloudy sky It is necessary discipline, and what scales and exercises are to the pianist, so is pencil drawing to the artist. One's hand grows sensitively obedient to the brain, and answers directly to one's power of observation, like the touch of a musician's hand upon the keyboard. He does not stop to calculate the interval which will produce harmony, but obtains it by an instinct which is the result of long practice, and so the artist's hand as naturally expresses what he sees The delight in the easy and competent expression of form is only surpassed by the delight in the expression of

colour, and those two qualities of sensitiveness to form and colour go to the making of a painter.

At first you will probably find sketching with the pencil irksome, but the taste for it will grow In spite of your inclination towards colour, you will learn to love it So certain will your touch become by persistent practice, that you will *feel* the drawing. You will get that something in the work which lifts it above the merely mechanical imitation, to that higher plane which is instinct with life In such study you will notice many things that had previously escaped your observation, and instead of making a laboured mess of your pencil drawing, your hand will answer to your eye directly and confidently.

The more you know the details of your subject, the greater will be your power to allot to them their due position and their due subordination as you observe them in Nature. Wherever you meet a conjunction of fine forms in Nature (which are so grouped as to appeal to your sense of style or of decoration), do not miss the opportunity of making a drawing of them They are not too common It is not necessary to make a detailed drawing, but sketch in the masses and the main lines of construction, noting how the trunks of the trees support the foliage. Mark the outlines of the branches and their shadows, then draw the principal lines of the landscape, and the outlines of the clouds piled above it, and the manner of their shadows You will thus have obtained the general facts of the character of your scene, and this is the first object of your pencil drawing. The second aim is not of so broad a synthesis Your object now is not the construction of the design for a picture, in which you have to transpose certain things that are not exactly agreeable in their natural position, (a change more easily effected in pencil than in paint), but to draw the details of which the masses are composed. You must note all the peculiarities of a tree. Draw its trunk or a section

of it, or a small bough, with each individual leaf. You will observe the manner in which the branches attach themselves to the trunk, and all the details of its construction, so that you will know how to use the tree in your landscape. The same method applies to other details, *i e* in your general sketch the hedge appeared a mere outline, soft at the top and stronger where it came in contact with the earth , but now it must be drawn in all the fulness of its detail. The form of each item which goes to make up the intricate mass must be drawn. Make a careful note of the various individual plants, as you may probably want some of them afterwards. This drawing will help you to a better understanding of the colour, which, as a luxury, you may subsequently indulge in Not only is pencil drawing most excellent practice for the landscape painter—it is also a pleasant means by which a large amount of knowledge may be obtained. You will be surprised how the quality of your line will improve, so that you will be able to convey the maximum of meaning by the minimum of effort You will find that your pencil will roam over your page, following the contour of the hills and trees with accuracy and feeling , almost involuntarily you will find the hand answering to your eye. For the etcher this quality is essential, and it is of the greatest possible value to the painter.

Pencil drawing, as I have attempted to show, is not only useful to you in your trials for a composition, in which you have faced the problem of transposition of the forms of Nature, but as a means of obtaining studies of materials which will enable you to suggest in the broad masses of your painting, the multitude of details which build up its breadth, and in such a way that although not literally drawn, they are so suggestive that they give one the satisfaction that they are complete

CHAPTER V.

COMPOSITION

PERHAPS the most elementary and yet one of the most abstruse qualities of landscape painting is composition The moment a painter places any arrangement of forms upon his canvas he makes a composition and at the same time encounters its difficulties. It is easy to recognise bad composition, and easy to avoid what is obviously wrong, but there is a very far cry between what is not bad and what is really distinguished. No one would think of taking Nature always just as she is; even the photographer with his limited power takes the greatest pains in the arrangement of the material before him. The painter with fuller powers has greater responsibilities, and if there be some excuse for the former in consideration of his limitations, there is none for the latter.

The problem of composition faces him at the very outset of his work; he may be quite certain of its importance in the other arts, recognising its claims in Music, Poetry, and Architecture. He may acknowledge that Nature has offered fewer suggestions to the sister arts than to the landscape painter, but suggestions of breadth, dignity and style, which she has offered each, are necessary to them all.

If the painter finds that rare thing in Nature, the happiest conjunction of the most suitable forms for a great composition, and he appreciates its worth, his appreciation is the proof that he understands what constitutes fine composition. If he cannot discern it in Nature, he cannot be expected to venture into that difficult field, wherein he assumes the authority to transpose his materials to

CHÂTEAU GAILLARD.

FROM THE PAINTING BY ALFRED EAST, A.R.A.

G

suit his purposes, and of selecting what he requires for the definite object he may have in view. In the art of composition he accepts the whole of the responsibility of his position, for either success or failure.

Since composition is an essential in the expression of art, one feels how important a few hints may be, for the landscape painter is surrounded by many pitfalls and snares, and the more he may love Nature the more difficult he may find it to avoid them. Innumerable unessential details, though attractive in themselves, may mean destruction to his composition. The authority to select is not only necessary but obvious. Therefore a painter must assume that authority to which, as a man, he has an undoubted right.

Composition is a convention founded upon wide principles. If it is not yet demonstrated why certain arrangements of form and colour give pleasure, and other arrangements give pain, it is not a question for us, but for the scientist. We know that it is so, and therefore, without going into the origin of the pain or pleasure, we must accept the facts as we find them. The finest and most prominent quality is balance; the sense of balance gives one the feeling of satisfaction. There are numberless means by which this may be obtained, each governed by certain conditions. The decorative artist has his special conditions, the architect his, as also in their sphere the poet and musician have theirs. We have to consider what those conditions are which govern landscape painting. This interesting quality of balance can be demonstrated by the steelyard arm, or the illustration of the balance of a pound of lead to a pound of feathers. For example, two pounds of lead would balance bulk for bulk—such a fact is too obvious to arouse one's interest, but the moment the bulk of the one is increased and the bulk of the other diminished, one's interest is instantly stirred, and the question arises as to what difference of

material causes the change of dimension So in the case of the
steelyard, the disproportion of weight, of course, determines the
placing of the pivot. if that be just, there will be a perfect balance.
Now imagine your pound of feathers, large in bulk, to be the
clump of trees, and your counterpoint on the other side of your
picture to be your pound of lead—*i e.* an object of a strong and
definite value—you recognise at once where the point is in your
picture upon which these quantities will swing. That point or pivot
is one of the most interesting parts of your composition, because
it is the *blind spot*, there, and there only can be placed any
accent such as a figure or figures in one's landscape which will
not disturb the *previously arranged* composition

Frequently I have composed a landscape without the introduction
of a figure, and afterwards, for the sake of scale—for everything in
art must be governed by the size of the human figure—it seemed
appropriate to introduce one, and I have always found that if the
composition was correct, the place for the figure was in the centre
of the canvas—*i e* exactly half-way between its two sides—and formed
the pivot which I have already described. On the other hand, if
you design a picture with the intention of introducing figures, you
would not of course place them in that position at first, but would
so shift the balance of the other objects in the picture, such as the
trees, sky forms, etc, as to make the introduction of the figures
agreeable, or in other words, to make the balance just.

Now a few words of practical advice Beware of equal quantities
of light and dark. See that the masses of your dark, such as trees
or houses, are not equal in form or area to your masses of light,
such as water, sky, or road See that the dark masses do not
divide the picture in two equal parts (See illustrations A and B.)

You will observe that the space covered by the trees in
Fig A (p 36) is equal to that covered by the sky, and not
only is there equality of quantity, but more or less equality

FIG. A.

of form. This will be better understood by turning the sketch upside down Such faults are frequent, and should be most carefully avoided owing to the repetitions of forms in Nature, but you will see in this example what not to do. Note that the form of the sky is practically the same as the rounded forms of the trees This danger, great as it is, is perhaps less marked than the inclination to repeat forms in Nature, such as the contours of the branches of the trees and of clouds The branches of trees offer you an opportunity of falling into the error more easily, since it is more apparent to the casual observer. Before speaking of the smaller forms of Nature, let me urge you to be careful, before you touch your canvas with a brush, to see that your big things are right If they are right, you may be sure the little ones will, more or less, take care of themselves Therefore, when you have a large canvas before you, the first thing to do is to determine on the scale of the subject you wish to paint. With a piece of charcoal you roughly outline the great masses as described in another chapter, and when you have arranged the masses of your material and found the scale, you decide how much or how little of the field of vision you can include within your canvas, and this can only be done by a number of pencil drawings in your book, or a number of charcoal outlines on your canvas. You have to consider what is the object of

FIG B

OPULENT AUTUMN.

painting the subject ; whether it be merely to make a copy of the material before you, or so to arrange the material that it will express the emotion Nature may have given you. You may elect to paint the large masses of the trees clear of the top of the canvas, or, on the contrary, you may choose to cut off the tops by permitting them to run out of the picture These matters are at your discretion , the fineness or poverty of the composition depends upon the discretion used

After having made up your mind how to arrange the big masses of dark and light upon your canvas, you will begin to discern that there are other things which call for consideration The question of tone, for instance. You will find that the tone of your masses, in relation to the tone of your sky, plays an important part in the matter. For example, it is easily understood that a small light looks more brilliant when in close contact with a deep tone than if it were surrounded by tones of the same value, although the colour might be different , the composition, therefore, may have to be modified through the darkness or lightness of the sky, or the contours of its forms. I find it better to paint the contours of my sky forms to suit the contours of my landscape You must always bear in mind that every contour in your composition is gauged by the right angle of your canvas and the edge of your picture, and in the relation to these lines should be the expression of the curves These contours have an essential purpose to serve, insomuch that they must express the nature of the material They should also be big in feeling and noble in design

I have pointed out that the curvature of any line is immediately seen by comparison to the edge of your canvas, and it will be understood that the scale of your picture will also be governed by it For example, a number of small curves do not convey the same sense of dignity and style as large ones if they be fine You see this in the landscape by Rubens in the Pitti Gallery (see illustration

facing p 39) This picture conveys no sense of style, it is all frittered away by several small incidents, each attracting the eye and not helping the general effect of the whole. How different is that by Corot! There we see but one intention expressed, and the introduction of the figures adds to the value of that intention You see in the former no sense of balance, while in the latter this feeling is so delicate that one touch more of dark or light would destroy its charm. In this illustration by Corot one sees the application of the general principle I have spoken of in the introduction to this chapter.

But here let me warn the young landscape painter against the imitation of the Masters A young man once said to me, that he was in great distress about forming a style, that when he went out on a misty morning he thought of Corot, and if the morning were breezy he remembered Constable I said, "Why don't you remember yourself? Aren't you a man?" That is what I want *you* to remember, and I say it again, at the risk of repetition, you are to work in the spirit of the old Masters, and not in the letter I do not want you to compose all your canvases like Corot because I point out to you one of his qualities, which stands out in contrast to the absence of that quality in Rubens I would advise you to study the work of Claude in his "Liber Veritatis", better still, Turner's "Liber Studiorum" (that Master who, whatever his materials were, always presented to you a noble composition) And then, if there is anything in you, you will form your own style The study of the works of these great men will help you to a better understanding of the great importance of composition. Each had his own personal way of looking at Nature, although their modes of expression were different, but they were one in the great principles that underlay their art

I should like to encourage you to cultivate the force and personal qualities which these men possessed, and if you have sufficient

LANDSCAPE.

THE RETURN FROM THE FIELDS.

FROM THE PAINTING BY RUBENS, IN THE PITTI PALACE.

Photograph by Anderson, Rome.

knowledge you, like Turner, could transpose your materials If
you have not, do not try, for you will come to grief The removal
of a tree, or the diversion of a road, or the rearrangement of any
smaller details will give you trouble, and that is a proof you do
not know enough of the principles of composition

One overlooks many little personal peculiarities and falsities in
great work if the essentials are right, and I would impress upon
you the necessity for bearing this fact in mind, that if the essentials
are wrong, no matter how beautifully the details are painted, the
picture cannot be a fine work of art. Your business is to express
big thoughts—big ideas, by big means—and it is possible to do so
without the sacrifice of truth to Nature There is no reason why you
should lose the characteristics of the particular tree you are painting,
because you make its contour finer, or remove it to another place
Trees differ as much in personal character as men You will find
noble forms and mean ones; they are at your option If you
paint a mean one which is not suitable to your purpose, simply
because it grows in the same vicinity as the other material you are
sketching, it is because you have not the power to alter it, or are
too lazy to attempt it either is enough to ruin your work

Let me ask you to look at Nature with wide eyes, a large
appreciation, and a broad, generous, and synthetic outlook, and if you
cannot express the splendour of her dignity and the breadth of her
repose, you may still do more than the man who thinks a pretty
hedgerow or a moss-grown cottage all sufficient for a noble landscape.

Having spoken of the larger qualities of composition, let me
point out to you some minor considerations, the aggregate of
which should assist you to build up a picture.

You may have rhythm, but be careful lest your rhythm degenerate
into repetition Do not let alliteration of form be obvious. Allitera-
tion is a distinctly charming quality in composition but it is a
dangerous one in the hands of the ignorant Look to your angles,

that they do not become too dominant. There are fewer things so "telling" in composition as a right angle, and remember that the moment you paint anything, you at the same time form the shape of something else, and in any large quantity of dark you have in a measure defined the shape of the area of the light.

You may see in the work of Ruysdael, and of other old Dutch painters, the most sincere effort to paint every leaf on the tree, a sincerity worthy of a better cause Notice the constant repetition of forms in their pictures; not only of the forms of leaves, but, what interests us more at the moment, the repetition of branch forms. You may see that Claude and Poussin did this, and so gave their trees an air of unreality It was not till Turner came and explained the matter that we saw in art the "happening" of Nature. As the method of painting trees will be dealt with in a separate chapter, I shall speak only of trees as material in composition I will only point out to you that the repetition of branch form of the same quantity and contour is to be avoided.

Remember the value of the human figure in composition A small figure will alter the balance of your composition much more than a larger surface of any inanimate object: its weight in the balance of your composition is out of all proportion to its size— even a large tree would not upset the balance of the composition so much A small light surrounded by darks has a much greater weight than a larger light in contact with a lighter tone, and a small dark on light has a greater effect than a larger light superimposed upon a half-tone Each touch, either of light or dark, forms a portion of your composition, and should be essential; for what does not really help must be a drawback A fine design is that which the slightest alteration will spoil an inch in a canvas of twenty-four square feet is sufficient to destroy the balance of its parts, and a good composition cannot be added to or subtracted from. It is complete. If it has given you a good deal of trouble,

and necessitated your making many studies, it is worth while, if only for the satisfaction of feeling that it is well done

There are painters whose work depends entirely upon the colour, they ignore the quality of composition for the sake of some

FIG C

minor truths. Believe me, when the colour goes, as it must in the course of years, there will be nothing left to speak of its excellence; if there is no beauty of design, then the value of the picture as a work of art will be lost Composition is one of the greatest qualities in art, it makes all the difference between a fine

work and a mean one I will attempt by means of a few illustrations to convey more clearly what I mean.

Fig C will convey no sense of composition; but the moment you place other forms across one of the masses in the form of tree trunks and clothe them with foliage, you produce an effect as in Fig D, which is not unpleasant, but you see you must introduce other forms to balance this addition, so you may *feel* your way to what is right. Then with the correction of line, and the addition of clouds, you have

FIG D

a balance which we call composition Examples might be repeated constantly. One may suffice (see Fig E), which is the reverse of the example above, in this the objects are not at each side, but in the centre of the canvas. This, as you see, is

FIG. E.

FIG. F.

FIG. G.

important, as the distances from *A* to *B* and *C* to *D* are equal, and the distances from *E* to *F* and *G* to *H* are equal. This is not right. The bulk of the trees and the distance from the edge of the canvas are the same. You may say to yourself, "What am I to do in this case? Can I put a dark sky in one side and light in the other, or can I put some trees and show the distance in the other — which would be the better?" You make the experiment, with this result (see Fig. F), and may paint a large tree to the right or left of your picture which destroys the sense of equal distribution. The painter can raise or lower this or that as he feels his picture requires it (see Figs. G and H); and when he has done this, he might take his mirror, and see what that most impartial friend says of his design; if it still holds good reversed, I think he may be satisfied that it is correct.

Some of the forms of landscape composition may be described as triangular (see "Moonlight

MORNING IN THE COTSWOLDS.

in the Cotswolds," frontispiece, and "A Berkshire Meadow," facing
p 51), circular (see "Morning in the Cotswolds," facing p. 42, "Lake
Bourget from Mont Revard,' facing p 6), or convergent (see "The
Lonely Road," facing p 64, and "The Aftermath," facing p 72), but
one does not think to what order any composition belongs, if it be good.

Remember that no spaces must be equal between the masses,
or between the masses and the edge of the frame; that the
lines should be in harmony as well as the masses. I mean that
the swing of the outline of the
tree or any object should not
be needlessly interrupted; that
the great mass of darks should
not be placed in sudden oppo-
sition to the lights, but should
be broken by half-tones The
sense of breadth and harmony
is thus secured But where
you wish to produce a very
strong effect, such as a storm,

FIG H

the hardness is modified by the dark sky One cannot throw
over all rules of composition without seeing instantly there
is something wrong, and until you can detect such errors, you
cannot hope to make a noble design. You must also think
of the quality of your material before you think of its dis-
position thus elms and oaks have a different effect to black
poplars, the first strong, the latter soft.

Bear in mind your linear as well as your aerial perspective
In your composition your lines should be sympathetic, and when
they are not pleasant in Nature and have a soft and sleepy
feeling, the refreshment can be obtained by a dark or light, but
more frequently by the addition of an opposing line which should
be led up to with great discretion and care

A picture of a flat country can be made into a good composition by the inclusion of a big sky (see " The Aftermath," facing p 72), and hundreds of other examples might be cited of the resources available for the production of good compositions, including the drastic method of cutting your picture down, or adding to it, a measure which you should not hesitate to adopt when all other means fail But do not do this impulsively Cover the parts to be cut with strips of brown paper till you get the exact proportion of parts, then get a new stretcher made to the size. Cutting down is a last resource, and should not be done unless the result would be a distinct gain, but it is sometimes necessary You may have painted your picture in too small a manner, the reduction of its size will then increase the sense of scale. You have, for example, painted your mountain, in an Alpine subject, too low in the picture—a common fault—and you feel it gives no sense of the height you wish to convey. It is too well painted for you to tinker with it, and yet something must be done By cutting a piece off the sky you at once give a sense of height to the mountain

To improve your composition your picture may require an increase of size. Such an alteration is invariably made at the top, but it is a more difficult matter to add to a canvas than to cut it down , an addition means relining, which brings many difficulties in its train, and should be carefully considered before such a step is taken I would almost go so far as to say that it would be better to repaint it, than resort to this.

There are so many interesting problems in composition, that it would require more space than I have at my disposal to describe them—the bearing of one thing upon another, the relative influence of lights and darks, apart from the sentiment of the picture. But this may be said of the art of composition, that it is one of the most interesting, though it may be the most difficult problem for the painter

EVENING IN SPAIN.

FROM THE PAINTING BY ALFRED EAST, A.R.A.

CHAPTER VI

COLOUR

WHAT is Colour? We understand well enough the general meaning of the term, but cannot easily frame a definition Some day, perhaps, colour will be defined as chemical compounds are, and described quantitatively, a definite figure being employed for a definite tone At present our definitions are loose, and we cannot explain the exact measure and meaning of our words when we speak of colour We ought to have such definitions as will leave no doubt in the reader's mind as to the tone the writer refers to, and we should associate the exact tone of a colour with an accepted symbol. We call yellow, yellow, yet there are a hundred tones of yellow, from the most brilliant suggestions of light, to the deep hue which lies on the borderland of red We have no names for these except "light" or "dark," and very weak epithets they are, and absolutely worthless to the artist. We say a sky is blue It may be so, but you would frequently be inclined to call it green were a fragment of that pigment held up for comparison

In the works of eminent painters we see the sky painted in a fashion that suggests all the qualities of atmosphere,—distance, the sense of infinity, etc,—yet if we were to compare it with Nature we should find that the picture which gave these revelations was painted many degrees lower in tone than the actual sky. So again with red It may be sumptuous, full, rich, expressive of dignity and power, or it may be poor, mean, and unworthy of its place; yet we call it "red" in either case On

one side it may coalesce with a blazing scarlet, or descend the purple slope towards blue If this indefiniteness occurs in the primary pigments, what shall we say of the secondary and tertiary ones, with their infinite range of subtle greys ? It would be an impossible task to follow and describe them. It is not within the capacity of the human mind to do so. We use names which are, after all, but approximations to the real facts

Colour cannot be expressed without a medium, or without the assistance of form, yet it has a quality independent of either It is the significant beauty of a pearl, yet, strange to say, it is of little value when the same lovely iridescence is shown in a meaner material We lose a vast amount of the enjoyment of life in the non-appreciation of colour in its infinite varieties and combinations There are within our minds associations of sentiment with colour For example, red calls up the ideas of force, cruelty, or passion ; purple speaks of dignity and regal splendour, and blue of purity, and so on But, for all that, it has not been discovered what form or shape best serves for their display , and if the most expressive form, let us say, of red be made, it may lose or modify its meaning through contact with its complementary. There is a wide field of unexplored thought in the question of colour and its bearing upon the emotions through art, but it is too abstruse for a book of this character It is sufficient for our purpose to insist that the student should recognise that there is as much artistic thought necessary to the selection of colour from Nature, as there is in the selection of form, and that no colour should be allied with form, if by such alliance that form should lose its special characteristic Our nerves may be as irritated by a series of tones of colour in a bad picture, as our ears would be by the discord of tones in music

We speak of " good " or " bad " colour These terms are entirely relative and conditional No doubt colour *quâ* colour may

be good or bad, but, from the painter's point of view, its quality is determined by its suitability to the purpose in hand The artist has the whole gamut of colour at his disposal for his own selection. If his selection is bad, he must not complain that he has not had the opportunity of choice It would be equally absurd if the musician complained of the quality of sounds, or the author of the nature of words Great thoughts have been expressed by simple terms, and great pictures painted with a simple palette

I mention this matter, because I want to warn you that no excuse is valid for the misuse of colour You cannot come back puling from a mis-spent month of work and say you never had a chance You have had chances as good as any of the greatest painters ever had It is entirely your own fault if you select colour that is common or mean. Some people see only the sordid elements in life and Nature; they seize only the non-essential things which Nature would almost seem to display in contrast with the truly great Philistine painters, mistaking these for the inner realities, and being oblivious of true place and proportion, reproduce them, and leave the characteristic things undone So with colour They see the obvious and superficial, they do not see what is distinguished and fine Unfortunately their appeal to Nature for justification is allowed by those who see her with the same meanness of vision

The appreciation of colour is undoubtedly a rare gift. With it a man can become a great painter, without it, he cannot possibly claim a position amongst them One can cultivate this faculty if it is inborn, and develop it to a higher plane, but if it is absent it cannot be created any more than you can create an ear for music. It is a well-known fact that faculties become atrophied by disuse, and exercise is necessary for the retention of natural gifts It is said that Darwin, who used to practise music in his early days, completely lost all sense of

it after a long period of life devoted to scientific pursuits He could not tell the difference between "God Save the Queen" and "Rule Britannia" You perceive, therefore, it is equally necessary, if we wish to keep the colour sense keen, to constantly sharpen that faculty by close observation and comparison of colours in Nature, learning to select those that will be most consistent with our purpose The vulgar craftsman will give you the rough, primitive colours that are seen by the crowd; but the disciplined eye perceives the qualifying effect of many different local conditions, yet never loses the truth amid these modifications. You have admired the beauty and subtle colour of the landscapes by Cazin You cannot say for certain what proportions of yellow or blue composed his green You cannot detect the particular pigment in his delicate greys But you instantly recognise that he has seen these tints in Nature, and that his representation is just and beautiful. You conclude that they are arrived at through a refined and artistic temperament, not the coarse and vulgar ignorance that paints blue blue, or green green, and leaves no message beyond the impression that the hand that painted was the hand of a boor

The lesson to you is this · While exercising care in the selection of your subject, its composition, and the effect under which you will paint it, you must think, and think seriously, of this vital question of colour It is a question of the first importance, and probably the most profound of all the difficulties you have to encounter If you are a colourist by nature, the time and thought you devote to the subject will not be wasted; naturally, by thought, you will add something to the fineness of your gift If you have but a poor appreciation of colour, it is all the more necessary to seek improvement by painstaking and persistent study.

It has been said, and said with truth, that if you look for any particular colour in Nature, you will find it If you search for

purple, you will discover purple; and if you want blue, the blue will be sure to show itself This curious and interesting fact in psychology accounts for the preponderance of certain colours in some artists' landscapes—a specific strain, as it were, running through them all, as particular notes in a musical fugue. We know a man's work by his predilection for a certain colour, yet the artist himself may be completely ignorant of the peculiarity.

It is possible you may become colour-sick, *i e* lose your quick appreciation of colour The only remedy is resolutely to exclude the offending pigment from your box, and to force yourself to paint the subject without it It will be difficult, and almost painful at first. You will be trying incessantly to find it on your palette, but persevere until you have conquered this abnormal tendency. Then, when you are so master of it, you may indulge yourself with a little of the forbidden colour as a luxury

The *raison d'être* of painting, in contradistinction to the other arts, is the expression of colour, or rather the expression of colour allied with form. It is a laborious task to secure some of the higher qualities of tone when using a full polychromatic palette It has been done by Turner, even if at the expense of other artistic qualities But do not allow any difficulties to drive you to seek that refuge of the destitute—painting in monochrome It is obviously easy to obtain qualities of tone in black and white. It is true we may even suggest colour in black and white, and there are artists who claim to suggest colour by a monochromatic scheme But do they succeed? That is a question I would ask you seriously to consider They paint black or brown trees, and a grey sky made of flake-white and ivory-black, and they perhaps insert a spot of colour in the figure of an animal or man. Now, had you not received the suggestion through the *form* of the trees that they were trees, do you think you would feel they were green? I think not You feel they are green

I

because you know by their form they are trees If the mass had not assumed the shape of trees you would not have arrived at the conception of any colour, but would only have perceived their blackness The suggestion is offered, and you accept it, your intellect coming to the rescue of your sensation by a process of deduction Were all art so colourless, what a monotony it would be; and Life minus colour — flowers, skies, seas, costumes, pageants, reduced to dull monochrome—would become a dreariness indeed It behoves us, therefore, not to shirk the difficulties of colour, but so to use it that it becomes a pleasure; for the appreciation of colour is one of the joys of life—one of its greatest charms It is our duty to cultivate this faculty—so to understand its value that we may reveal its beauty to others, and which many, in their hurry of life, may have missed

The greatest landscape is marked by the alliance of fine form with fine colour Colour that is harmonious and just will always possess beauty Forms should be enhanced and glorified by colour, and colour in turn should be ennobled by being enshrined in the most appropriate forms. It is said that one of the old masters declared that he would paint the head of a Madonna with mud, if he were given colour to put round it

A BERKSHIRE MEADOW.

CHAPTER VII.

TREES.

TREES are to the landscape what flowers are to the meadow, they decorate it Who does not love trees? They are associated with us from the cradle to the grave. They mark the events and incidents of history. They are the only living recipients of old-time stories Generation after generation they have listened to the same story of love. They have sheltered from the sun and rain, the king and the wayfarer alike. They are planted as mementoes of great events. From the landing of Joseph of Arimathea to the coronation of our King, they have fulfilled this monumental quality. How many songs could we sing of trees? From the oak, the ash, and the rowan tree, in every language, in every land, they are intimately associated with the requirements of man. With what joy does the traveller see across the dreary desert of hot sand, the oasis of palms, or the sailor see them rising in their verdant beauty on the lip of the horizon of the ocean! Shakespeare, Wordsworth, and a hundred others speak of them. These writers have their favourites as Balzac had, when he called the black poplar the noblest of trees. One could continue writing of their dignity, grace, and beauty. It is our business, however, to paint them, and how difficult, how subtle one finds them ; loving them as one does, knowing them so well, one feels how wonderful they are, here caressing and enfolding the homes of mankind, or there standing out against the sky on some wide upland, strong,

simple, dignified, and great Let us treat them with the respect they deserve, and learn to know them so well that we can enter into their moods, whether it be when the rude winter has torn from them their foliage, or when the spring gives them new growth, or in the sumptuous splendour of their summer adornment. These peers of the nobility of Nature are entitled to the first place in the consideration of the landscape painter. He loves them for their kindliness, he respects them for their stately dignity. The great landscapists have expressed this love of trees; some have seen in them one quality, and some another All have attempted to realise the essential place and position in their art.

I have suggested in the chapter on pencil drawing that you should draw all kinds of trees By this means you will learn the peculiar characteristics of their growth, under different conditions of soil and environment, and obtain greater knowledge for painting them. Having described how you should draw the contours, and the shape of their branches, and the shadows under their branches; their construction, the manner in which the trunk supports the branches, I must now attempt to speak of how they should be painted. The successful painting of trees against the sky, I think, is one of the most difficult problems of art.

You have already designed your picture as to the quantity, the space, and shape of your trees , now you have to consider their colour and character. After you have blocked them in with the rest of your landscape, broadly and simply, as the whole " lay in " must be, you may, at the next painting, paint the sub-masses with the rest of your picture , then next the smaller masses and so on, something like a pile of coins—the first painting broad like a crown, the next over it like a florin, the next like a shilling, a sixpence, and a threepenny-piece. That is how you paint a tree, each painting being a step nearer the realisation of your aim, which must be to paint your tree in exact relation to the land-

MORNING AT MONTREUIL.

FROM THE PAINTING BY ALFRED EAST, A.R.A.

scape in Nature, and on your canvas in exact relation to the rest of the picture. This is essential.

The proper lighting of a tree is another word for modelling. Trees are rounded objects, and therefore must not be painted as flat tones. They are living objects and must be painted so as to express their vitality. That brings me to the point of their edges which come against the sky. In no part do they realise the sense of their vitality so much as where their moving leaves are marked against the sky. Here they are seen, and here their shape and action are most strongly felt. If we look at a photograph, the edges of the trees do not give you the feeling that the tree is a living thing, they are marked with hard precision against the light, like a solid building, and yet at the same time if we see them in Nature we hear the whisper of their leaves and know that they live and breathe. To express *that*, is a greater truth than the camera can reveal, and a higher form of realism. Of course, the edges will vary according to the species of trees, and also according to the different conditions of effect. For instance, trees against the light appear different to those upon which the light is shining. An oak against the setting sun is a very different object to a birch which is bathed in the full glare of sunshine. Again, the speed of movement of the leaves against the sky gives one a different impression. The elm moves slowly and so has a harder edge than the black poplars, which quiver in the east breath of air, and must be so painted as to suggest that characteristic quality. If the eye follows the movement of the leaves they appear hard against the sky, but if you look at the tree, and not at the individual leaf, you will recognise the truth of what I say. For example, look at the plane-tree leaves which almost touch your window in your London home; you can mark their shape and colour, but look at the plane-tree leaves on the opposite side of the street and you can only see the aggregate of their

leaves. You know that the aggregate is composed of the same kind of leaves that are near you, and from your knowledge of that fact, you wish to paint them, but you cannot What of the near ones, if the distant ones were so realised ? You could not paint them more real than life. So remember this great truth, that there is as much beauty in the aggregate of details as in the details themselves.

Let us watch the action of a leaf on a black poplar. It may first offer us in its movement a surface which reflects the sky, then as it turns from us, the thin edge is only seen, then it turns back again the reflective surface, and showing an angle by which its actual form and colour are revealed. These are phases, each affording us the reflective surface and the silhouette ; this is but one leaf If we bear in mind that all the leaves are moving more or less, you will come to the conclusion, if you think for a moment, that round the edge of the tree where the leaves are against the sky, the edge must be made up of an aggregate of these movements They are also turning at different intervals of time. For instance, while one is a silhouette, its neighbour may be at the angle of reflection, and another showing the thin line of its edge where all the intermediate movements are going on. Now you cannot paint actual movement in your picture, but if you paint the edge of a tree which combines the silhouette, the reflection, and the edge of the leaf and other intermediate positions of the leaves, you will obtain the *sense* of their movement, which is such a desirable quality. The act of movement means life, and life interests us, for we are living beings ourselves. Dead things are abhorrent to us, and we put them out of sight.

I remember an eminent painter saying to me, " I *see* foliage hard against the sky as an edged mass " I answered, "So do I, but I do not *feel* it so."

J

You may depend upon it that if you think that the imitation of Nature is the end of landscape painting, then I need not write another line, for no explanation is required, no directions needed The painter is simply to sit down and paint what he sees ; if he does so, he has probably pleased himself, but he has deceived others. Imitation is not art, and in the imitation of things one loses his own personality, he is a menial, not a creator; and if he is willing to give up his authority over the created things which were intended for his use, he cannot have any hope, and there is no faith in him The slavery of imitation is terrible. If the painter cannot give us something he feels in Nature that others have missed, why paint at all? There is no place for him

Look at a picture by Corot, Constable, or Turner, or any of the really great painters of landscape, and see how they suggested in their different ways this sense of movement, which would be absolutely lost were we to imitate the actual and instantaneous fact of Nature at one moment of observation. The real value of an instantaneous effect lies in its suggestion of other effects likely to precede or to follow, but the copying of things at the moment of arrested action is absurd. This is revealed by the camera. For instance, the position of a race-horse in violent action seldom gives you the sense of movement. It is simply the photograph of the fact, but does not convey to one the sense of speed, which is, after all, the principal fact to be recorded. The edge of a tree, as I have said, is a succession of soft and hard accents. In your first painting you will have painted the edge of your tree with a tone of colour half way between the tone of the tree and sky, a little lighter than the tree and a little darker than the sky. Never mind if it is smeared over the exact shape you desire When you paint your sky you can correct that. This half-tone may be made of cobalt, rose madder and white, with a little yellow ochre to

ELM TREES.

qualify it. It should be of a pearly grey—the tone which Lord Leighton used to say was the sub-tone of Nature Now this sub-tone at the edge of your tree is waiting for those accents caused by the varied movements I have described. The silhouette is the definite and darkest touch; and the leaf upon which the fullest reflection is seen may be painted with the highest light (Constable used almost pure white) and the sub-tone is the suggestion of the many, being seen on edge. By far the greater proportion are seen in that position than in silhouette or the angle of reflection, therefore this tone will express the greatest quantity. This may be after all but a clumsy explanation. You must study Nature for yourselves, I simply put you on the track.

Note how Corot painted the edges of his trees by the simplest possible means, and Turner by reducing the intensity of his colour Every painter has his own method, but all have the same end in view Each must solve the difficult problem in his own way in seeking for the truth.

Now let me speak of the " bones " of the trees See that your trunks and branches are solid things. Strong and hard by contrast, they, too, will help to suggest the movement of the leaves Now comes the difficulty of the interstices, *i.e.* the light shining through the trees. See that they do not upset your composition, for the next greatest accent in a landscape to the human figure is the light seen through a tree, for it is generally in proximity to the darkest shadow The right-angle of a branch and trunk, in the centre of your tree, with the sky beyond, forms a counterpoint in your picture, which, if not justly placed, will completely upset the balance of your composition. It is the most assertive thing in its whole appearance, and if it is necessary to include it to support the characteristic growth of your tree, be careful that it does not spoil your composition. You know that the colour of the sky seen between the interstices of the tree is the same colour as the

wide expanse you have in your picture. So it is in Nature; but paint it so, and immediately it will "shout." You must lower the tone, or you will spoil the *ensemble* of the work by unduly attracting the eye to one particular spot, and so destroy the

STOW ON THE WOLD. (SOFT GROUND ETCHING.)

breadth of your effect. This is another example that the truth in Nature is not always truth in Art. You must reduce the tone of the sky as seen between the open spaces of your branches to give you the sense that it is actually of the same colour as the general body of sky, though, as I say, it is actually some degrees lower.

ON THE OUSE.

One word more. The great advantage of painting your sky to suit your landscape (as described in another chapter) is that you can paint into the sub-tone, covering part and leaving part, and by so doing you advance that feeling of the movement of the leaves against the sky.

You must, as I have said before, find out yourself, by careful study and observation, how this is to be done, bearing in mind that the greatest realism is the expression of the vitality and character of the thing painted.

CHAPTER VIII

SKIES.

IF you make a practice of painting a sky every morning with the regularity that you take your bath, you will find at the end of six months that you know something of its variations. Perhaps the most convenient medium for this purpose is watercolour or pastel, but do them in oil by all means if you can, though the time lost in setting your palette robs you of the limited time you have at your disposal, for the clouds are changing every moment. Half-an-hour is sufficient, for I do not want you to make the practice a fag, or to take too much of the energy you must reserve for your ordinary work. Therefore, if you devote the half-hour immediately before breakfast to this purpose, you will find it the most convenient time of the day. Be sure you *draw* your sky, and if you cannot finish it in the limited time, paint that part which is interesting. You can take a few notes in writing on your paper or your panel, as the case may be, of the characteristics you have not caught. They, with the bit of colour, will be most useful. Apart from their use as studies, you will find that the practice will widen your knowledge of what is likely to happen under certain atmospheric conditions. Do not forget to date your sketches and note the hour, and the direction and strength of the wind. If you paint a clear blue sky, you may make a study of its tone and gradation, its warmth or coldness. Or you may have one of thin high cirrus, where the detached cloudlets float miles above you, interesting individually, and still more interesting in their aggregate. You may note how they are lit, and how

64

THE LONELY ROAD.

FROM THE PAINTING BY ALFRED EAST, A.R.A.

far the light impinges upon their edges, or influences the effect of their density, as shown by their opacity or otherwise. You may watch a wandering piece of cumulus moving at a lower altitude under the influence of a different current of air, and you will see how advantageous its form is in contrast with the mottled appearance of the cirrus. You will see the interesting phenomenon of one cloud passing under the shadow of another which has just intervened between it and the sun; and as it clears itself from its eclipse, you will note the revelation of its modelling by the contour of its shadow

You may find one morning high masses of cumuli, such as we see after rain, moving slowly and majestically across the sky, towering up and up, till their tops outvie the highest mountains, you will note their form and movement, their edges defined against the blue by a line which is felt rather than seen, giving them, with the shadow on the opposite side from the sun, their rounded forms How nobly they sail across the sky, or, on a hot day, hang tranquilly in that ineffable blue which is so difficult to paint. You observe the distances between these masses; you see the perspective of one great cloud behind the other, how they slowly approach, till at length they form a great spectacle of white and soft grey Through their interstices you get a glimpse of the blue, made many times more intense by its isolation As the day grows to noon, they pass along their celestial path till, in the evening, they shelter themselves on the line of the extreme distance, where the low sun lights them with his effulgent glory Above the belt of long strata they lie, gradually changing from grey to gold, from gold to purple as the sun's rays slant upwards from behind, and gloom rests upon the purple hills. It is absorbing thus to watch a sky from dawn to sunset (say in September when the days are short enough to do so), and one may profitably devote a whole day to the study when

K

the sky is particularly interesting In the sketches I have
given you facing page 90, you will see that they all represent
the same scene, but in different aspects, from dawn to sunset,
and they illustrate not only what may be made of a common-
place subject by the selection of an effect, as I have stated else-
where, but the enormous importance of the relation of the sky
to the landscape.

Do each sketch at one sitting, which must of necessity be
short You will find a great deal to learn that you had not
anticipated You will see shadows, reflections, and reflected lights,
all which, carefully observed, build up the wonder of your sky
and, if painted well, cannot fail to be interesting and beautiful.

Let me give you a few hints about painting a sky In
the first place you must, as I have just said, do it justice in
one painting , but before making the attempt, prepare your
canvas with a coat of white, tempered with yellow ochre, which
should be painted with crisp firm touches, using very little
medium, the touch firmer and stronger as your work extends from
the horizon to the zenith Beware of a dead flat surface , do not
brush it too much, as in painting at all times your touch should
be confident After the preliminary coat of paint is dry, you may
scrape off any unpleasant projections left by your brush at the
previous painting, and you will have a very agreeable surface to
work upon Then with white and yellow ochre you paint it
exactly as you have done before, taking care to cross the brush
marks, and after you have done this you paint your blue into the
wet paint You will discover that your blue will be a little stronger,
since it will mix with the wet paint which forms the ground

I will now speak of painting a plain blue sky, since I have
already spoken of clouds and their treatment The blue must, of
course, depend upon the colour in Nature, and that which is in
sympathy with your landscape , but, generally speaking, your sky

A COMING STORM. (FROM A SOFT-GROUND ETCHING.)

palette is composed of the following —White, yellow ochre, cobalt
or French ultramarine, viridian, and rose madder or Venetian red,
very much diluted with white Now paint a touch composed of
the first four. If you find it too intense a blue, add a little more
white and yellow ochre and a mere touch of raw umber If you
find it too green add more blue and white. Then with different
quantities of the slightest possible difference of colour, paint
another touch by the side of the former ; then paint one with a
distinctly red side, another to the yellow side, another to the blue
side, and another to the green side ; then step back and see the
general effect, which, of course, should be blue At the horizon
you will see no blue, or scarcely any; in its place use the
slightest touch of raw umber or Venetian red and yellow ochre,
according to the effect You must be careful, for you will find
the merest touch of blue is too much, and is most extraordinarily
deceptive

Your extremely distant sky should be painted with small,
independent touches, edge to edge, with the slightest possible
difference of colour, very much diluted with white, but still
a difference which can be detected upon very close inspection
These should be placed at the horizon, in a contrary way to the
prismatic arrangement, and this method, instead of giving you a
rhythm of colour, will give a feeling of vibration, because the
tones will be very slightly contrasting or complementary, so that
you will discover, although looking like a flat tone, it is really
composed of many separated colours This is one of the most
difficult things to accomplish, and you will, no doubt, meet with
many failures. You may get it too light or too dark at first, and
too near in perspective , but never mind failure, try again, for
when it is properly accomplished you will have given the impression
of great distance, and of moving air, heated by the surface of the
earth. You have now to join the colour of the horizon with the

AN IDYLL OF COMO.

FROM THE PAINTING BY ALFRED EAST, A.R.A.

In the possession of E. B. Marriage, Esq.

touches of blue you have already placed on your canvas higher up
The gradation must be very carefully done, still following the
method of placing the colours side by side, increasing the area of
the touch and the necessary slight alteration of colour, more blue
and less of the warmer tints, until you join the blue, which is the
general effect of the sky Your warm touches are now more or
less deepened with blue of slightly different shades, but of the
same tone, until you reach the top of your canvas, where you can
have large passages of plain colour Now carefully look over the
sky as a whole You will probably see that your gradation is
much more abrupt than in Nature That is to say, your sky
changes more suddenly from the distance (where it partakes more
or less of the colour of the extreme distance of the landscape) to
the blue of the zenith. But that is as it should be, for if you
take the relative space in Nature that you have taken in the
picture between the horizon and the top of your canvas, you
would find that the gradation in Nature was very small in that
limited distance By the quicker transition you obtain that sense
of infinity which is a greater fact and of more importance than
the actual truth.

I spoke of the necessity of painting a sky at one effort I did
so because of the difficulty of patching blue after it is dry The
difference of colour in drying makes it a most troublesome thing
to do For instance, when the painting of your sky is dry, and
you paint upon it exactly the same colours which match it when
wet, the change in drying, slight as it is, is sufficient to reveal
the patch, and there is imminent danger of losing the aerial
feeling which is its predominant quality, and having to do the
work all over again. But of all things avoid a flat sky There is
nothing so miserable in landscape painting as a mere piece of flat
blue No matter how beautiful and just the colour may be, if
you cannot get away from the fact that it is paint and nothing

but paint, if it fails to suggest to you the infinity of the sky, it is wrong How little there is in the skies of Poussin, or Claude, or in later times, of Stanfield and others, to give the impression of this aerial quality They are too often merely suggestive of a pattern of paint How different are those of Turner, Cox, and Constable, which, though differing in their mode of treatment, all show in common, these qualities of infinity and distance There are other means of painting a blue sky than that which I have described, I would not for one moment deny that, but I have described the manner by which I know from experience how these essential qualities may be obtained.

In conclusion, I wish to draw attention to the tonal " pitch " of your sky. Since it is quite out of the question that you can get the exact tone of a sunlit landscape, it must be some degrees lower than Nature It stands to reason that your sky must harmonise with Nature, and further the composition and colour of your trees and grass must also be in sympathy with the forms, as well as the colour, of your sky. And as you cannot alter the composition of your trees to suit your sky, your best plan will be to paint the forms and colour of your sky to suit your trees That is why I advise you when laying in your first painting, simply to paint a preparatory ground for your sky, which is afterwards to receive its final painting. When your landscape is partly done, the preparatory painting at that stage will, of course, receive your careful attention. Don't be afraid of rubbing the foliage into the sky, and the sky into the foliage at your first painting You will have ample opportunity of getting the character of the edge when you are painting the sky at a later stage, and then the very greatest care must be exercised in the matter

It is useless to lay down any definite rules on cloud forms suitable for any particular picture, because there are so many

factors which govern and qualify them The sky must be felt upon all surfaces which are capable of reflecting it, not only in the pool of water, but from every blade of grass, from every flag by the waterside, from every leaf, roof, and road That is what may be understood as being in sympathy with the landscape Always remember that it is the reflected light of the sky added to the local colour of each object that makes up the general tone of the landscape It is not only sunshine and distance that give it colour, but an aggregate of a million little reflections * The essential truths of the sky are its immensity, its infinity, and its purity Aim at securing these qualities, and you will have a fine sky Let your landscape be in relation to your sky, and your sky to your landscape In so doing you will certainly have attained some of the high truths which go to make up a worthy picture

* See chapter on "Reflections" (p 77)

CHAPTER IX.

GRASS.

IT would obviously be stupid when painting a landscape, to paint every leaf and every blade of grass. We want the general character of the material, and that we cannot secure without careful observation of the factors of which it is composed.

Go into a meadow on a sunny day If you look at the grass facing the sun, you will notice that it is of the most brilliant green The sun shines through the uppermost blades, penetrates others through the interstices of the first, and reaches so much of the remainder that practically every blade is deluged with rays that filter through the very substance of each leaf and compel it to transmit its hue to the eye. Then turn and look in the opposite direction *from* the sun. You will see that the grass instead of being a bright green is of a silvery green grey, this is because you are standing at the angle of reflection of the majority of the blades, which catch the light of the sky as it shines upon them, and not through them Only here and there occasional blades show a rich green to qualify the general greyness The aggregate of a field of grass is made up of infinite details of colour, and its character is affected by countless little reflections, whether of the deep blue of the zenith, or of a passing white cumulus cloud

Have you ever noticed, when a meadow is being mown, and you happen to face the sun, the rich hue of the standing grass, through whose stems the yellow-green light penetrates in a brilliant glow? Examine the same grass when it is cut and lies in long swathes behind the mower. How grey it now appears! The

THE AFTERMATH.

FROM THE PAINTING BY ALFRED EAST, A.R.A.

ך

infinity of leaves through which the sun awhile ago was freely shining, now reflects the summer sky at innumerable angles, and the result is the revelation of one of the most lovely combinations of colour in nature.

It is important to remember the difference in colour of grass at dawn and sunset The grass in the morning is greyer than in the evening, because in the former the light is reflected from myriads of dewdrops, whereas in the latter the reflections are from dry surfaces

A difficult thing to paint is grass in perspective. One knows in looking across a wide meadow there is a considerable difference in appearance between the grass at your feet and the grass in the extreme and intermediate distances. As the material is so uniform in colour and texture, the difference is less perceptible than in the case of trees and other objects, which by their diminution of size add to the sense of distance, and are more easily placed in their proper perspective. But in a large flat grass field of even surface it is indeed difficult, and requires the greatest study and closest observation before you can realise the fact of its extent and its flatness How many come to grief in this respect, and depend upon such aids as trees, cattle or anything of a known size to assist them to realise its area In many cases if you took away these aids, you would have nothing left but a stretch of plain green, standing on edge, with the complete loss of the sense of its being a level plain. How is this to be avoided? The grass in the immediate foreground, which is near enough for you to see if you look closely, is composed of many shades of green; some blades transmitting the light, others reflecting the tint of the sky, and others presenting their own local colour. You will also observe there are differences of colour as well in each blade, some darker or lighter, some deeper in tone or less pronounced You

L

will see here and there withered stalks and a hundred details which break up the mass. There are clover leaves, sorrel, dandelion, plantain, and many other weeds which, taken in the aggregate, build up the general colour. In your immediate foreground it is possible to realise one or two of the most apparent of these, but a little further off it is difficult, and further off still it is impossible. The intermediate distance must not be so broken as the foreground, and the extreme may be flat. The contrast of this flat paint to the broken paint of the foreground will be another aid to perspective. Other things, too, will help you, as for instance a cloud shadow, a distant church, or a winding brook or river. But none of these incidental objects should lessen your effort to realise the *character* of grass.

It is quite an easy matter to get the exact colour of things close at hand. The representation of still life is comparatively easy, there being practically no room for dispute as to the local colour of the objects. For instance, some beech leaves in a glass of water can be imitated, so far as colour is concerned, by the merest tyro in art; but when the same leaves form part of a tree standing some distance away, the problem becomes a test of judgment and skill.

Looking at the grass as a mass you are conscious that in the immediate foreground of your picture you must realise the feeling of all its differences of colour and texture, which is made up of a hundred subtle differences of material, the predominant colour, of course, being green. Now as you see these broken shades of green in the foreground in Nature you must break up your pigment into the various shades of green without any attempt to realise individual blades of grass.

Do not mix your colours on your palette; take a little of each (pure) on your brush, and place them on the canvas. If you find the effect a little too cold, you can correct it by a

warmer tone in the next touch If you find it too grey, you can lighten it by a little transparent oxide of chromium or cadmium, and so on; but put the touches down separately and firmly, and unite them at a subsequent painting The distance will be painted with a flatter tone, and will be of a greyer quality of colour You will observe also that some portions of the grassy expanse are stronger in colour; more yellow and blue will then be required, and more vigorous green. Or it may be that some withered stalks alter the local colour, and you will want reds and yellows, with a dash of flake white, of course, to qualify the pigments A bushy tuft occurs here, a smoother surface there, and so on To represent the host of qualities which unite in the making of the whole field demands patient study of these and all such details Grass grows up from the soil, but it does not follow that the paint should be put on in upright strokes all over the area occupied by it Were it so, your picture would resemble green velvet Some portions of your grass are indeed aggressively erect, but others lie prone These latter, and more level patches, if carefully painted, impart greater individuality to the prominences of the upstanding grass.

The accent of flowers can be taken advantage of with profit, also the red sorrel stalk and the nettle These touches will be suggested by the means already described in the course of the first painting, or they may be added afterwards If you notice passages that are too obtrusive and broken, it is a simple matter to flatten them down, but, as I have said, it is necessary to have these flatter passages. The distance can be made flatter, but let this be in your first painting after the rubbing in, and the next painting will consist in emphasising passages and introducing here and there groups of details hitherto omitted And do not overlook the rule that when shadows overlay your grass, the same method of broken colouring will be revealed in the

shadow as in the open light, except that the tone is lower, and that the shadow, as such, will bring its special tint to the general effect If you do this successfully you will be astonished to find how nearly you express the general feeling of Nature.

For painting grass I should use white, yellow ochre, French blue, No. 2 cadmium, transp emd. ox chromm., and rose madder; sometimes a warm grey of raw umber and white, a long-haired brush, and plenty of confidence and paint

MORNING SUNSHINE.

CHAPTER X

REFLECTIONS

IF you have been to sea you may have noticed that the colour of the water was mainly due to the reflection of the sky The motions of the wind and ocean currents throw the waves into many angles, which reflect portions of the sky at various lines of incidence If you cross the Channel, you observe a difference in the colour of the water when you face the sun or turn away from it. You know the water itself is the same, but it has varied with the appearance of the sky. The sea, like the land, derives its tints from numerous causes. The clouds, in all their transformations from dawn to sundown, affect the result, and to their reflections must be added the mutual inter-action of lights and shadows among the waves themselves

Have you watched the agitated surface of a rapid stream? It displays an immense variety of lights and darks, more baffling than anything else in natural phenomena Its movement is so quick, the colours of the reflected objects are so diverse, as to render it almost impossible to portray its interlacing and inter-mingling forms. Only by the most persistent study, first in a series of drawings of a simple passage, and then of a more involved passage, can you attain thorough mastery of both facts and the method of treating them Perhaps the simplest stage in the study would be an examination of the reflection of some individual object, *e g* a light-coloured pole standing by the edge of the water. It has, we will suppose, a background of dark green trees, which almost cover the area of its reflections. You will see the contortions of its shape produced by the swift altera-

tions in the surface of the watery mirror. At the base of the reflection, the line of the reflected pole is broken into quivering fragments This is accounted for by the interruption of other reflections at other angles. You will observe that the movement of the reflected forms are coincident with the movement of the water, and at the edge of the stream the object is more defined; and as it gets nearer the centre it is broken up or confused by the more rapid movement. But, supposing the stream was still, the reflection would be almost a replica of the object. But, if you find it difficult to draw the reflection of the pole, your task is increased when you come to its background. You not only have to represent a light object against a dark space, but a confusion of many colours thrown across the moving surface.

There are other conditions which lend attraction to the study of reflected trees in water In the case of an absolutely still surface, which reproduces the scene distinctly, the reflected object presents a different figure, owing to the angle of vision of the object itself varying from the angle of reflection.*

It is not necessary for my purpose to go very closely into the principle involved My present aim is to encourage the student to observe, and he will reap ample reward in the many surprises of this fascinating research. From rough to smooth water you will find the reflection altered according to the motion of the water at the surface Perhaps the most effective point, but not the most difficult to seize, is when the water is slightly agitated by the air, and the reflections are lengthened into long strips of colour to the foreground The charm of this particular effect is perhaps most striking on large sheets of inland water The surface may be so agitated as to produce lengthy reflections of sky tints, which create a more vivid feeling of liquidity than if the water were still Take again, the reflected glare of the sun upon water on a sultry day.

* The student might read " Light and Water," by Sir Montagu Pollock Bart

The heat has dimmed the mountains with a soft haze, and the sleepy lake lies like an inert mass of molten metal The very air seems thick with heat, and all about you is a sense of its throbbing pulsation Nothing seems to move except by the disturbance of the heat waves. A fish leaps, and the broken surface of the water reflects the sunshine in an instantaneous flash Or you may have seen some floating rushes. The capillary attraction pulls up the water till it presents a reflecting surface to the sun, and reveals an edge of intense brilliance which it would be impossible fully to realise with paint.

Have you noticed also the sun at noon on a hot August day, how its heat fills the air with a quivering mirage, how everything that is seen within a certain distance from the earth's surface seems to be vibrating? You actually *see* the heat, and its peculiar effect upon the lower sky, which, practically speaking, is clear You wish to give the sensation of it in your picture Every sky which is clear and big with a low landscape horizon gives in a more or less marked manner this sensation along its edge At the zenith it may be quite calm and pure, a vast expanse of perfectly placid blue, but by noon along the hot fields you observe the heat shimmering and vibrating with a growing effect upon the flat fields, until the figures of the harvesters in the distance, and the cattle and the horses, are distorted by the strange radiation. The sun's reflection is sometimes caught in looking from a height upon a river between the trunks of trees The light cuts out the substance of the intervening darks, and, in some places, where the trunk is slender, apparently divides it This glare of intense sunshine cannot be entirely realised As usual, a compromise must be made, and if that compromise gives you the feeling of the actual fact, then it is justified I may say in passing, that the white of the palette does not express light. Break it with yellow (not mix it) and you will find that it suggests a higher key, although in

reality it is of a lower shade than the actual white pigment Similarly the juxtaposition of certain pigments, so broken that the predominant feeling of the colours is the same as that of a flat tone, may give one a sensation of vibration, although appearing in the general arrangement of colour values as a flat tone

Roofs of houses by reflection may reach a higher pitch of light than anything else in the landscape, and make a most interesting feature, and one which probably conveys the idea of sunshine better than any other detail of your composition

The beauty of reflected colour may contribute much to your design. I can recall the reflection of the sublime Fuji-yama across the water in the Lake of Hara, ending amid the interstices of the amber rushes at my feet. Beyond the mirrored blue of the sky, the snow peak, and the mystic grey of the shore gleamed a strip of pale rose colour One would have supposed this to reflect the sky immediately above. But no; it reflected another part of the heavens Innumerable wavelets, ruffled by a passing current of air, had caught up the tint of a rosy cloud, and transferred it to a remoter part of the lake.

The reflection from sunlit grass on the under parts of a white cow, combined with that of the sky on its back, is a puzzling thing in paint; but it is far worthier your brush than the exercise of painting the cow in the shadow of a fold-yard, uncomplicated by reflected lights. I was once asked to criticise a picture of cows under an evening sky, and I made the comment that it was not painted from Nature "Why?" inquired the artist. "Because," I replied, "you show no reflections of the eastern sky upon the surfaces which would in Nature throw them back to your eye" We admire the beauty of reflection in a crowded street on a wet afternoon The lamps have just been lit, and they are repeated with many variations in the puddles. The pavement reflects the wayfarer, giving its own local colour and accepting others.

On a bright day there is an enormous amount of reflected light from the sky, which subdues the colour and at the same time raises the pitch of light, the result being the loss of that richness one sees when the sky is grey. To view the full brilliance of colour in any country, you must see it under a grey sky. You have probably remarked the difference in this respect between England and the South. Not only is the landscape greyer by reason of the local colour of the component parts of the landscape, but it becomes so in consequence of the more pronounced light. A scarlet dress in an English scene looks brilliant, but the same object transferred to a street in sunlit Cairo would melt into its surroundings. In Egypt, the glare of the sun is so strong that the houses add to their native whiteness a blazing reflection which defies paint, and this circumstance drove many artists to darken the sky—a conventional device which only defeated its own end. The object which they failed to achieve by this means was to represent the all-pervading light and heat, which lend so distinct a feature to Egyptian scenery. So, again, the physical effect upon one's eyesight of reflected light in the desert, or on an Alpine snow-slope, imparts a sensation which endures in one's memory. But though that glow may be realised partially by words, its brilliance can be much less adequately conveyed by painting.

Note the reflection of the grass upon the trunks of trees near the ground. By painting this reflection you will at once get rid of the hardness which most amateurs betray.

Do what Corot did. Walk round your tree, examine it narrowly, and learn to know it thoroughly before attempting to paint it. Note that not only is the colour of the trunk altered by reflected light, but every leaf, while always in colour in sympathy with the sky, reflects light and colour according to its surfaces. For example, leaves with an absorbent surface, as the elm, do not reflect the sky as brightly as those with a smoother surface. And always

M

remember that the colour of a tree is built up by the aggregate of the colours of its leaves. You will have noticed how within the shadow of a white-washed wall across a sun-lit street, there gleams the reflection of the shining road. The light is reflected and ie-reflected again like an echo. Remark also that the depth of water is indicated by the character of the reflections on its surface. Shallow water reveals the colour of its bed within the reflection of dark objects. Note on a rainy day the hundred phenomena of the wet streets, and you will see things that will come to you as revelations. The other day I saw in a river a submerged boat. I perceived distinctly its ribs and seats. Without changing my position, when I half closed my eyes, I saw nothing but the reflection of the sky. Upon the same factor of sky reflection depends the just modelling of a tree and its branches, and you should not set out to reproduce foliage before you have conscientiously studied the action of reflected light

A thousand things in Nature are beautified by reflections, which give animation and vitality. Reflected light makes the edge of a stagnant pond sparkle like a necklace of diamonds. It touches the scythe which severs the dank grass; it illuminates the ferrule of the carter's whip until it glistens like the sceptre of a king, it vivifies your subject, and gives a soul to your picture. It should always manifest its presence. It is easily forgotten in the studio, but not so readily when one faces Nature. There is no excuse for the painter, let his scheme be ever so decorative, who neglects the aid of a quality which often adds to, and can never detract from, the dignity of his work. If I may so define it, it announces the sympathy and unity of Nature,

" Kissing with golden light the meadow green,
Gilding the stream with heavenly alchemy "

CHÂTEAU GAILLARD.

FROM THE PAINTING BY ALFRED EAST, A.R.A.

CHAPTER XI

DISTANCE.

THE colour of distant landscape varies in a thousand ways, according to the conditions under which it is seen. In Italy, for instance, a distance may be supremely blue, while in England it may be a varied commingling of tender greys. In this country the distance often merges into the sky, so that it is impossible to see the line which marks the actual division In Scotland, on a clear autumn evening, when looking towards the sun, the distant hills are often of a simple tone of deep purple, but with the low light of the setting sun shining upon them, every detail of the variegated cultivation, scraps of rock or patches of heather, etc, are revealed We know how distant these objects are in Nature, but how to realise that sense of distance when painted in this high key of colour is a most difficult problem. We know that certain objects in Nature are at such-and-such a distance from us, and our knowledge of the fact prevents us from depending upon the sense of judgment by colour We do a mental sum in miles instead of making a close study, as we should do, of the difference of colour values The diminution of form is resorted to before we begin to think of the difference in colour. This arises from the fact that it is so easy to judge the size of a known object, such as a house or figure, and from that we almost unconsciously express our opinion. I say "almost," since it is not always the case, for we frequently hear the exclamation from someone who gazes from a height, " How small the people look !" This is an example of the constant

appeal to scale as a proof of distance The road winding through
a valley, a row of poplar trees, or distant houses are tangible facts
They diminish in form as they recede, at the same rate under all
atmospheric conditions But what shall we say of colour which
is governed by conditions of atmosphere in its wonderful changes
from dawn to sunset? Not for an hour is the colour at any
given distance the same Almost imperceptibly it changes in
sympathy with the sky, and vouchsafes fresh revelations of character
as the general volume of light increases and wanes through the
long summer day Observe the shadow which started with a
long line down the hillside, creeping on till it hides itself behind
the brightening trees, and throws itself like a blue-purple line
across the winding road The cottages, which were dark before, are
now white as marble patches on the sapphire background of the
sky The river, which wound below the hill in modest grey, now
flashes back the burnished gold of mid-day, whilst the sun marches
triumphantly on its course, each step adding a new beauty in place
of each departing charm The glamour of heat makes the distance
magical. It vibrates and scintillates through and over all things,
and gives mysterious changes to the scene we saw hours ago in
the young light of the morning. It fills the landscape with a
glistening flood of reflection. Every leaf in the foreground which
holds its face upwards laughs back to the glory of the sunshine,
and the far-sweeping distance throbs in its strange effulgence
There are no shadows visible now, except from the near objects,
as the sun is high above us, and the whole of the distance is
bathed in light. We are struck by the breadth and beauty of
illumination, but to convey the sensation by our painted canvas
is an end more easily desired than attained

One should notice the colour effect of this heat glamour, in its
multitudinous variations The artist should absorb it into his
memory, for it is infinitely more beautiful than we deemed possible.

EVENING SONG.

FROM THE PAINTING BY ALFRED FAST, A.R.A.

I know of no master of the old school who has attempted to conquer this problem I know of few pictures in Europe which, since landscape painting became an independent art, have adequately expressed the wonder of it Yet it is evident, to the observant eye, almost every summer day, it is, perhaps, one of its most familiar effects It is known to all, yet painted by few. I would not counsel any student of landscape painting to attempt it at first, particularly in its influence on distant colour, until he has overcome the less formidable effects Let him select an effect when the shadows reveal the modelling of the trees, or lay their grey veils over hill or road He will find it hard enough in all conscience without essaying the most difficult Distance under any conditions is sufficiently baffling It is a subject that demands, yet repays, the most diligent study A beautiful distance which leads the eye through and beyond the *paint* of a landscape, is one of the charms which unfailingly appeals to the lover of Nature and Art

I will endeavour to furnish you with a few hints that may be profitable and instructive. Let us imagine a landscape comprising trees and a grass foreground, across which a path winds over the ridge of a field in the middle distance Stretching among its undulations, a river skirts the sloping field and is then hidden by intercepting trees or the elevation of its bank. At the back, the grass fields and ploughed lands recede towards the sky line We know that grass afar off is green, it is composed of the same material as the grass at our feet, and the natural inclination is, of course, to judge the colour by our knowledge of this familiar fact But let us take a test case Here is a hillock close to our feet. If we lower our face, so as to bring the grass of the foreground on a level with the grass lands of the distance, we find our conception of the colour of the latter completely upset It is a grey, and not green, and of such a quality

as to suggest the distance between them Between the two colours thus juxtaposed lie all the variations of tone that intervene between the nearest material and the more remote. The nearest grass is the positive green of its local colour The colour of the distant grass may be obtained by white, cobalt, yellow ochre, a touch of rose madder and raw umber , and when seen through a haze (an effect so difficult to paint), you will find that yellow ochre, cobalt, and the least suspicion of rose madder (all suppressed, of course, with white) will approach the tone. But only experience can tell the exact proportions of each colour suitable for the purpose. The lower sky must be painted at the same time as the extreme distance. You may have observed that these are nearly the same, the alteration of texture and treatment being all that is necessary to suggest the difference

A MIDLAND VALLEY.

FROM THE PAINTING BY ALFRED EAST, A.R.A.

CHAPTER XII

SELECTION AND TREATMENT OF A SUBJECT

THE *raison d'être* of the existence of the landscape painter is that he can discern and reveal to us beauties in Nature which cannot be revealed by the sister arts He delights in his expression of Nature, and trusts that he may interest others; but if he is a true artist he is not over anxious on that score Great work is always in advance of public appreciation. It has been so in the past, and is likely to be so in the future

The selection of a subject is a problem which faces the painter at the outset of his work. No matter how beautifully a picture may be executed, if its subject has been filched from the domain of literature or music, it is, from the highest standpoint, a failure When you go to Nature to select a subject, remember there are others, employing other means of expression, who also wish to tell the story which she inspires Bearing this in mind, you may be able to find some subject which can only be expressed suitably by the painter, and with that conviction you should have confidence sufficient to carry you through to a successful issue Therefore if you have a method of expression different from (though not necessarily better than) that of the poet, or musician, you must learn in what that difference consists, lest you all unwittingly stray into their domains. I do not say you should not paint a literary subject, but you should not paint it merely to express its literary aspect You can, or ought to be able to, add to the literary allusion new meanings conveyed by the charm of form and colour

Excepting what I have said, it is your privilege to take what you want from Nature, you are free to make selection from the material before you, but be sure your selection is such as can be best expressed by painting Therein lies your responsibility. In the matter of selection, too, there arises the problem of the possible overcrowding of a picture The artist feels he cannot paint everything, and the question is—what *shall* he paint? He is forced to make his selection from subjects in his district, and as he descends to details, the task of selection becomes more and more difficult Half-a-dozen artists may paint the same subject under the same conditions, and yet how different are the results! That is because one has been influenced by one thing, which specially appealed to him, and the others have been each affected by other qualities Every result will be more or less like Nature, but all will differ from each other Now imagine these six artists painting the same subject, but each selecting for himself the particular effect under which he would paint it, the difference then would be very much more marked One might think that the early morning effect best suited the simplicity of the landscape, another the light of noon, while a third might feel that the evening glow of colour gave the best effect to the material

I have painted eight sketches of the same subject under different effects to illustrate my meaning (See facing p 90) These sketches will probably bring home to you the truth of the responsibility of the artist in the treatment of his subject, and the particular effect under which he elects to paint it The selection is left to his discretion entirely, it is for him to say which of the effects from dawn to sunset he will choose. If I ventured to give him any advice at all, it is simply to say, paint the effect which best harmonises with the landscape—that which most enhances the beauty of its leading characteristics. In this selection he will show what stuff he is made of, for, as I have

said, he is a free agent, and Nature offers such an ample choice that there is no excuse for failure The artist who loses his opportunity may attempt to shelter himself behind the assertion that his picture is like Nature There are many bad pictures very like Nature in some respects; but such a claim is inadequate, for the painter may have represented Nature in her worse mood, and under the most unsuitable conditions It is absolutely necessary that the subject for painting should be selected with this consideration fully borne in mind You cannot shirk your responsibility, so do not rush to a decision lest you have to beat an ignominious retreat

The first aim, then, in the selection of a subject for painting must be that your subject conforms to the limitations and conditions of your art, and it should be such an one as cannot be better expressed by any other branch of art

Secondly, see that you paint your subject under conditions that will best bring out its special characteristics.

Next we must consider what are the qualities essential to support its characteristics, and what are non-essential Nature is so prolific in her offerings that selection becomes an artistic quality of the first order. It is astonishing what one can see in Nature if one is predisposed to look for it. Some painters see Nature almost monochromatic, others see it polychromatic. One sees the immensity of its details and analyses its component parts One may look for the big facts, and another for the little ones. One is moved by the simplicity of Nature, and another by its complexity. Perhaps the highest and rarest gift is the power to see the big things of Nature, the real essentials, those which reveal and stamp upon the mind of man those fundamental qualities by which it is expressed. If an artist can so discipline himself when painting from Nature as to accept only those things which are great and

N

characteristic, and paint them in their true relation to each other, i e in their just values, then his pictures will possess that quality so difficult of definition which we call "style" Let me caution you never to be tempted to paint a landscape because of some accidental prettiness in it Such an impulse is always dangerous, and sometimes fatal, to the success of your work I have known a person to paint a six-foot picture in order to include a distant mill or church. If he had reflected for a moment that this church or mill covered exactly one square inch within twenty-eight superficial feet, he might have seen at once the foolish waste of his effort Do not be tempted by anything, no matter how charming it may be in itself; remember it can only be beautiful for your purpose in so far as it assists your general scheme

I have said that you should not try to embody in painting an idea that may better be expressed by music or literature But you may of course go to Nature with a preconception, such as a sentiment of dignity or repose. This sentiment may have been begotten in your mind by some suggestion in poetry or music, a suggestion which seemed to you not fully realised by them, and which you felt you could better express in painting. With such an idea in your mind you may go to Nature for the materials to realise it. You will not find these materials in conjunction, and you may not find them close at hand, but knowing what you want, you will be able with patience to bring them together so that they appeal to the spectator with the convincing truth that they were actually in conjunction in Nature This is a high quality in the art of landscape painting. The artist is born, not made, but to attain such success, he must go through the toil of study until he is confident that he knows enough of Nature to transpose her forms if necessary to his requirements. "May I,' you ask, "take a tree from this place because its form and outline suit my composition, and put it here, in the place of a

1. STORMY DAWN.

2. EARLY MORNING.

3. NOON.

4. CLOUD SHADOW.

5. STORM.

6. SUNSET.

STUDIES

7. MOONLIGHT.

tree in Nature that is not so suitable to my purpose?" Yes, you may; there is no law forbidding. You have as much right to replant your tree as the peasant who planted it there originally Only see to it that your transferred tree appears as if it naturally grew there; let it be lighted at the same angle as the one it displaced; let its shadow have the correct form and extent, let the aerial perspective be identical with other trees in the same pictorial plane, let the painting of it be as confident as the rest of your landscape. Then you will probably elicit the remarks from those who see the picture, "What a charming place!" "What a delightful scheme!" etc. People will often visit a spot where some famous landscape has been painted; they see that the material is there, and that the picture gives one a true impression of the place, but there is very little like the actual arrangement of those materials. I have been sorry for some who, having taken a long journey, discover that the charm of the picture they had admired rested not altogether in the natural beauty of the scene, but in the art of the man who has transmuted the scattered material into one precious unity This is the function of art, to endow man with an authority to use Nature

Though the selection of a subject is one that requires discrimination, a fine work of art is not altogether dependent upon the subject, no matter how beautiful that may be, but rather upon its treatment For example, we may see pictures of Venice which realise the facts of that beautiful city to the fullest, but they cannot for one moment be compared to the wonderful glamour of one of Turner's works. He has treated his subject so that it exceeds in beauty the most wonderful effects in Nature. In his treatment of the facts of Nature they become transmuted, and that which is apparently poor and sordid becomes glorified and grand No doubt the treatment of a subject depends upon one's temperamental attitude toward Nature That is well, for as

I have said before, it is this personal quality that makes the different expressions of art so interesting and stamps upon them individual character and distinction.

In the eight sketches which illustrate this chapter, you will see that I have represented the same subject (a very simple one) in its varying effects from dawn to sunset. There is little or no difference in the arrangements of the trees and fields, the bridge and water, yet how great the contrast between No. 1 and No. 8 These sketches give you suggestions of the possibilities by which any subject can be painted in different ways. But had I selected a finer subject, the result would, probably, have been still more interesting If the illustrations show you the outward form of Nature under different conditions which reveal the subtleties of morning and evening, with but little material by which to express their peculiar glamour, how much more beautiful would the dawn or sunset be when associated with really fine material, which would assist the peculiar qualities one associates with these fascinating moments. Note, for instance, the real background of Turner's " *Sun of Venice* going to Sea " Revealed by the camera, one sees a row of buildings—interesting enough as ordinary dwelling-places —with all the hard details of their construction ; but with Turner, they are almost veiled by the glamour and mystery of the morning With a sight of the picture, a thousand thoughts and associations of ideas crowd into our minds which the photograph does not even suggest. The glamour was not created by the accurate and faithful delineation of the material, but by that magic of treatment which raises the picture to the splendour of a work of art. I am fully aware that my readers cannot all be Turners, but they may cultivate that insight of Nature that can see possibilities of splendour in the ordinary landscape around them

THE "SUN OF VENICE" GOING TO SEA.
FROM THE PAINTING BY J. M. W. TURNER, R.A.

VENICE FROM THE LAGOON.
From a Photograph by Alinari, Florence.

CHAPTER XIII

PAINTING FROM NATURE

A GREAT deal of discussion has taken place as to the advantage or otherwise of painting large pictures direct from Nature. A school, calling itself the *"plein air"* school, made this principle their party-cry. There may have been a reason for this, as landscape painting had become to a large extent a mere formula, a combination of recipes handed down by the old conventionalists, and had the odour of the studio; it wanted a breath of fresh air to revivify it. The *"plein air"* school did, in some respects, accomplish this, although its methods may have been pushed beyond legitimate limits, but all the faults combined of the new school were better than the artificial procedure of the older method. Painters awoke from their lethargy, and felt that in the freedom and individuality of the example of Constable and others a new era had arrived, in which it was possible for art to make advances parallel with progress in other departments of human achievements, though it was years before the more natural attitude received its due recognition. Artists now posed their peasants in the open air, and painted the effect of sunlight upon them, from immediate observation, and studied with direct vision the subtle effect of light, shade, and colour. Landscape painters took out their large canvases to Nature, and painted the subject before them on the spot. The difficulties were not lessened. But the question arose "Was it possible by this method to secure the freshness of Nature, the sense of its atmosphere and illumination?"

Undoubtedly it was, but difficulties beset the path of these men, which have still to be faced and overcome The great danger was of following the changing light instead of painting an effect of the moment It frequently happened that, in the large landscapes so painted, the effects of sunshine were crossed, that is, that instead of being positive as in a sketch, they were distributed or expressed with more or less hesitation and lack of definite purpose It was difficult to avoid falling into this error. The temptation was always present to paint the thing one saw at the moment, forgetting that five minutes later the sun would be blazing upon a surface which was now in shadow If the effect of light on that portion of the picture were true to Nature, by the time you had painted it, the effect in another portion of the picture would be false. The only way out of the difficulty was to paint for a short time every day while the effect was on, at the same time correcting the values and having the courage to retain them while finishing the picture Of course, this plan would not insure that you had the colour scheme before you long enough to get a satisfactory result, but you would have your sketches to keep you right in respect to the large masses of your subject. If you ventured in the spring to paint a picture of apple-blossom, probably you would find that the blossoms would have faded before the picture was done * Or you might paint a subject that mainly depends upon its colour The rain descends, your large canvas is brought indoors, and by the time the weather has again become suitable, the whole of your effect has changed, it no longer offers the attractive combination of colour which

* I remember a painter, who was a determined "sticker" to Nature, starting a picture of apple blossom He commenced his picture well ahead of the full development of the flowers, and with dogged determination made up his mind to "go for it" He painted the blossom with painstaking efforts to realise it according to his ideal of perfection Conscientiously he altered his picture with the changing aspects of Nature, till, at length, the blossom vanished, the full-grown leaves appeared, and the young fruit was developed When I saw the picture finished it was called "Gathering Apples"!

A GLEAM BEFORE THE STORM.

FROM THE PAINTING BY ALFRED EAST, A.R.A.

had induced you to paint it Such are the difficulties one has to contend with in painting a large picture from Nature The difficulties, of course, diminish with the reduction of size of your canvas, since you have a greater command over the smaller area If, therefore, you care to make the experiment of painting, say a five- or six-foot picture, direct from Nature, you should, in the first place, make sure that the subject is not liable to rapid change When you have discovered one that excites your enthusiasm, start by drawing an outline of your composition in charcoal, using as big a stick as possible When you have done so satisfactorily, re-draw over the lines with a lead pencil, then brush off the charcoal , but before doing so, it is as well either to rub your canvas down with pumice stone or wash it with benzine to take off the greasiness of its surface before starting. That had better be done before you draw upon it

Now since you have made your drawing you can begin to paint Set your palette generously Don't, for heaven's sake, use a starved palette ! Be prepared, if I may so express it, to waste all your colour sooner than get a thin picture Have your dipper big enough to take a large brush Assuming then that you have set your palette with plenty of white, and the colours arranged as I have already described,* start to paint with confidence Work freely from your shoulder, with your large canvas upright and at such a height that you can work standing—that is, the centre of the canvas should be a little lower than the palette hand, so that each part can be reached without fatigue Paint in your large masses broadly—which you will observe in Nature the more readily by half closing your eyes—but in their absolutely correct values and right relation to each other ; look for the contours of your lights and darks, then paint fearlessly and frankly Do not at this stage worry about details,

* See Chapter III , "Sketching from Nature" (p 14)

but look for the large things, remembering that the shape of one
mass forms the shape of the mass of another. For instance the
outline of the trees describes the form of the light of your sky.
Your subject must be reduced to its simplest proportions. Broadly
speaking, it will comprise but two or three salient quantities. The
darkest are your trees, the lightest your sky, with the grass forming
a middle tint. Of course this remark is merely a general one
These masses may, and will, vary according to the subject you
are painting. But what I insist upon is, that in the preliminary
stage of your picture you paint the effect that you wish to secure,
and as you cannot begin with details, the only plan is to block in
the masses with a big brush while the effect is on This should
be done at a single painting if possible

Do not trouble about anything else. If for example you cannot
paint the whole of the foreground, paint a passage of it, so that it
records the exact colour in relation to the trees above it; and pro-
ceed in like manner with the sky It is essential that all these things
which are chiefly affected by the rapidly changing effect must receive
your attention at the moment, a splash of colour of the right tone
is better at this stage than the careful drawing of the contour of a
branch, for the one effect is transitory and the other will wait

Before you commence a large picture, I should strongly advise
you to study your subject for some days, and to see it under
various aspects and conditions. It is not pleasant to discover,
when the picture is half finished, that it has not been painted
under the best effect Such study is not lost time, for apart
from your definite purpose, there is the knowledge you gain of
Nature You become so intimately acquainted with your subject
that you know how it is put together, and of what it is composed
You should also make sketches in colour under the same con-
ditions you elect to paint your picture, and also make pencil
drawings to familiarise you with its forms Do not think such

AFTER THE FÊTE.

FROM THE PAINTING BY **ALFRED EAST**, A.R.A.

energy is misspent. Curb your impatience to get at your picture; I know it requires an effort to do so, but believe me, the wider your knowledge of your subject prior to painting it on your canvas, the greater are the probabilities of success I would almost go as far as to say that you should know it well enough to paint it from memory, but that would obviously be travelling beyond the range of painting direct from Nature The advantage of painting from Nature is that you gain confidence. Confidence comes of knowledge, and that means spontaneity, one of the qualities which can be worth nothing if it is not obtained by intense consciousness

You have now, we will suppose, your six-footer covered—never mind how roughly or how broadly, as long as you have correctly laid in your values I do not know if it is necessary to explain what I mean by values. As we use the term in art, it means the truth of one tone in relation to another as compared with Nature For example, if I pitch my picture as near as I can to the pitch of Nature, and paint one passage exactly of the same intensity or tone as the same passage in Nature, I have struck the key, as it were, in which my tune must be played. I can, of course, transpose it by striking a new key I can paint the passage I speak of in a lower tone, but all the other tones in the picture must be lowered in the same relation to one another as they are in Nature For instance, I call the pitch of Nature " A." Say that in Nature it is glowing sunlight, and that it is impossible for any pigment to reach so high a key of colour, I am forced to lower my key to " F." In Nature all colours are in relation to " A," and in my picture, in which the " A " has been reduced to " F," all my tones must, of course, be in relation to " F " If there is 40 per cent difference between the light and shade in Nature, there must be 40 per cent. difference between the light and shade of my picture, no matter what the pitch of my picture may be.

o

At this moment, do not concern yourself with finish , you have meanwhile presented your subject in its simplest proportions If it has been expressed in a high key (and I should always advise your doing so), the various masses of colour should be in exact relation, and the resulting harmony gives the quality of tone. Step back fifty or sixty paces from your canvas, and you will be pleasantly surprised to find (if these conditions which I insist on be observed) how like Nature it is, for the distance in diminishing its size has made you unaware of the absence of details Your picture should now wait till it is dry. You have, I hope, painted it with a generous brush, and very little, if any, medium. You have put on the paint with due regard to the texture of the material before you, and in order to prevent cracking, two courses are open to you—either follow the method as described, or continue your picture while it is wet, which is the more difficult to do.

The danger of cracking arises generally from the superimposition of fresh colour upon a tacky or half-dried surface, more particularly in the case of a fast-drying paint over a slow one The fault of cracking is not caused by the inferiority of paint or of medium, but by carelessness or indifference in the actual process of painting The safest way, when painting a large picture from Nature, is to let it dry thoroughly after you have finished the laying-in, and see that it is thoroughly dry before you begin to work upon it again Flake white dries in a few days, but as it dries from the surface it may mislead you ; although it appears to be quite dry, you will find that it is only superficially so, and is not solid underneath the skin On the other hand, if you use zinc white you know that if it is dry on the surface it is solid underneath The advantage of flake white is that it works more freely and is more elastic than zinc, although it yellows more quickly by time, while zinc white, when quite hard, has less elasticity, and its brittle quality lays it open to some objections.

I use the new flake white (see p 10), which, I think, has some of the good qualities of both without their drawbacks. If you have used this white, which dries from the bottom, you can, where necessary, scrape off any obtruding brush marks that have been left in the excitement of making the *ébauche*, or first rub in If you use the ordinary flake white, which dries from the top, you must be careful in scraping lest you make an ugly scar, which will afterwards be difficult to disguise A cuttle-fish bone is safer to employ than a scraper, since it grinds down the surface evenly

You must now "oil out" your picture with a little poppy oil, rubbing it well in and wiping off all that is superfluous Then, with as big a brush as possible, you may recommence the correction of your masses. In this stage of your picture, keep it well under your command. Do not under any consideration attempt to finish it or any part or portion of it Still direct your chief attention to the *ensemble*, and disregard details Keep the whole thing as simple and as fresh and spontaneous as possible Do not be afraid, and do not hurry, and if your progress is apparently slow, never mind. You have made a real advance A bad work is more often the result of hasty and ill-considered finish than of defective skill. Continue to paint thoughtfully, closely observing the essentials, the big facts of the truth of light and shade, of the relation of colour to colour, of contour to contour, modelling the branches of your trees, painting with broken colour your foreground of grass with plenty of paint, so treating it that the brush marks will suggest the material Always remember that each touch must have a meaning, some useful purpose to serve towards your desired end As you paint you also draw. The brush must develop the truth of form as well as of colour You are, at this stage, building up as it were the various surfaces for the reception of a final finish, and that will evolve itself without effort Your picture will finish itself, for finish is simply the climax of self

criticisms and of careful balancing of effects and relations in comparison with Nature. The treatment of Nature in art is greatly a matter of the personal temperament of the painter. If an artist is attracted by the small things in Nature, which are no doubt in themselves very beautiful, he will seek to reproduce them, and the result will, in the estimation of those who are in the habit of looking for little things, be very satisfactory and highly finished But if these details are of no service in the expression of the large essential verities, then they are worse than useless Aim at the great things, which *include* the details, making them subordinate as in Nature, and placing them in due relation to the whole. If on the other hand you concern yourself with petty though possibly charming trivialities, they may worry and fret you because they hinder your appreciation of what is great.

In correcting the surfaces where the brush marks are not consistent with the material represented, you must bear in mind that there is a perspective of texture For instance, the extreme distance in the sky and landscape must not show the coarse texture of the foreground. The remote sky always gives one the feeling of having a fine surface which changes as it rises to the zenith. That is my impression, and I paint it so The same principle holds good in the landscape itself, I feel the texture of the distance to be smoother than the foreground, and the difference, expressed on the canvas, increases the sense of aerial perspective. You will of course have a knowledge of the elementary rules of linear perspective, but the perspective of the landscape painter is not so much concerned with actual lines as with imaginary ones. He must bear in mind that the land is more or less flat, and not an upright diagram with the diminishing objects as the only proof of distance. The one great strong line in Nature is that which is felt rather than seen, upon which the mountains base themselves, and the

AUTUMN IN THE VALLEY OF THE OUSE.

FROM THE PAINTING BY ALFRED EAST, A.R.A.

undulations of the fields appear to follow Upon this imaginary
line everything rests, and it must be felt in any landscape that
aspires to strength and certainty

The landscape painter must carefully study the influence of
atmosphere upon the lessened dimensions of remoter objects, and
remember that his tone values must be just, and this is inti-
mately associated with the truth of aerial perspective For
instance, if a yellow tree appears on the same plane as a green
one in an autumn landscape, it will be easy enough to portray them
in their right size in relation to your foreground But a difficulty
may arise when you try to paint them both in the same
atmospheric plane. It stands to reason that, if an equal breadth
of air intervenes between you and both trees, you have a colour
problem to deal with now, for it is essential that they appear by
reason of colour as well as size to be at the same distance from
the observer The lesson to bear in mind is, *that your aerial
perspective must always be consistent with your linear perspective.*

Remote objects occasion difficulties, no doubt, but do not try
to make them recede by diluting your foreground colour by the
addition of white You cannot reach the result by such means;
you must have a different set of pigments The strong hues of
your foreground, broken, as in Nature, into a hundred details, may
be composed of cadmium of three grades of strength, of rose
madder, and white, with burnt sienna broken with white and trans-
parent emerald oxide of chromium, and transparent golden ochre.
All these are broken together on your picture (see Chapter III,
"Sketching from Nature," p. 14), not mixed on your palette But
for the extreme distance your colour should be mixed on your
palette. For the intermediate distance you use paint not so flat as
in the extreme distance, but not so broken as in your foreground

You have now, with plenty of paint and very little medium,
practically repainted your picture You have gone over most of

the surface, except perhaps the shadows, which should not be thickly painted You have modelled your trees, painted the middle distance, prepared the foreground with broken colour, and, above all, you have retained the original freshness of your effect—that first impression which imparted vitality to the subject

Now let me speak of the sky. It is as you left it in your first painting—merely a ground of white, toned with yellow ochre. You will probably have seen many cloud forms pass during your work up to this point, and you know in your mind, which will best harmonise with your composition But still it is better to watch when your effect comes on, so that you may note the particular colour of the sky in relation to the trees, and in the same relation of colour paint it in your picture. But one moment—the form of the clouds that you perceive yonder may or may not suit your scheme You will be fortunate indeed if they harmonise absolutely No matter how beautiful your clouds may be, if they do not suit the contours of your picture you must avoid them, and accept only such as support and complete it, and are consistent with the character of the day You must paint the sky again with the same tint as you used previously, a little warmer at the horizon, and cooler above Then mix the blue on your palette, rather more strongly than is really needed, for the reason which I have already explained

You are now ready. You watch for your effect, which is coming on. You know it occurs at the moment of impact of that shadow upon the mass of trees which you have noted before It is the supreme crisis when everything, as it were, will sing in tune The clouds roll majestically forward and reveal the very form you desire You are, of course, standing at your easel No man ever painted a great sky sitting You hold your breath in the excitement of the moment, you know what it means to your work , but do not hesitate, do not flinch Take up the blue in

your brush and draw the sky, which will give the edge of
the clouds. Watch with attention the exquisite gradation of
tone where it shows itself above the cloud to the top of your
picture, to where it touches your extreme distance The form
and colour gradation of a good sky will convey a sense of per-
spective as truly as the landscape below You have now secured
the tone and form of sky which is in sympathy with the other
parts of your picture You have painted in your blue, so little
after all, but with a risk out of all proportion to its area Your
clouds may be now modelled with more deliberation, painting them
with grey at the undersides—a grey composed of rose madder,
cobalt and yellow ochre. (See chapter on "Skies," p 64)

If the under painting be properly prepared, the sky should be
finished at one painting, though this purpose must necessarily
be governed by size and other obvious circumstances But
what I want you to do now, and what is at this point of
more importance, is to paint the sky into the edge of the trees
You will remember how in another chapter (see p 54) I discussed
the method of dealing with this borderland of sky and foliage

Your picture having been brought to this point, you begin to
feel you are within measurable distance of the end Here I
suggest that, if the conditions of Nature are favourable, and
there is no probability of a change in your subject, you should
give the canvas a rest in order to let it dry Again bear in mind
that you cannot patch blue If you have failed in the sky, the
better plan is to take it all off to the under layer with an ivory
palette knife and begin afresh. So few artists paint a blue sky
well because they try to patch up the blue. It is difficult to paint
a white cloud on a blue sky. It will always be a patch Of
course, after many years of experience you may be able to venture
on some things which it would have been insane to attempt at an
earlier stage, and this of adding blue to blue is one.

Your picture is dry; you have oiled it out, and taken it to Nature again. You may have thought the time consumed for the preliminary studies was wasted, but, believe me, it is by these studies that you gain the knowledge and confidence which enable you to reach a successful issue.

Suppose it had commenced to rain, and continued raining, or that the atmosphere had remained grey for some considerable time, and at the end of this period the weather cleared only to reveal the fact that the trees and grass had completely changed their colour! What then? As I have said before, your studies would be of the greatest value as reference. Here you find the benefit of the policy of making careful sketches and studies before commencing your picture But if you are fortunate enough to have a continuation of suitable weather, you will have the opportunity of comparing the component parts of your picture with each other and Nature during the time the effect is maintained

You now watch keenly for the subtle and more indefinite passages of colour, such as the reflected or re-reflected lights which give it quality As style depends mainly on the dignity of your composition, so quality depends upon the realisation of the more indefinite variations which make up the masses You now select from Nature just those things that will sustain the character of your material Your trees cannot show every leaf Although there are those who have thought otherwise, like the old Dutch landscape painters, they have come to grief You must realise what is infinitely finer—the portrayal of foliage so as to indicate aggregation of leaves in the suggestion of the mass Your painting must give the sensation that the masses of foliage are made up of multitudes of leaves, though they are not separately indicated. A house in the middle distance you know is built of bricks, but you would not for one moment think of depicting the individual courses; you would treat the wall as a tone of colour,

EVENING IN THE COTSWOLDS.

FROM THE PAINTING BY ALFRED EAST, A.R.A

and let that suggest the material Or, take another case Under
the trees some cows are resting, and the sunshine dapples over
them a pattern of light and shade You know full well that
the red and white, and the light and shadow of their hides,
are composed of multitudes of fine hairs, but you do not
dream of attempting the task of painting them. At the same
time you should not paint the cattle as you would a door,
with flat paint that would reveal nothing of the truth of the
material it is intended to represent So with trees and grass
Our knowledge informs us that the grass field on the distant
hillside is green But hold up a few blades of the same
material at arm's length for comparison, and you will find that
the apparent distant "green" is not green at all, because of the
effect of the intervening atmosphere You have to paint it so
as to render the same impression as that of Nature, and to
convince the spectator that though you paint it a yellow or blue-
grey, it is identical in colour with the meadow at your feet.*

Many illustrations could be added, if necessary, to emphasise
this principle, but I have said enough I think to convince you of
the absurd notion, promulgated by some, that the closer imitation
of Nature in detail shows greater knowledge It is not so The
subtler knowledge of Nature is evinced by the artist who knows
Nature so well that he can adapt it to his own purpose It is so
in all things The writer and the musician proceed on the same
method It would be absurd to say that the mere reproduction
of natural sounds is music, or that a faithful description of a
locality in a guide book is literature I remember an exhibition
of landscapes which were submitted in competition for a prize
Although the prize was offered for a landscape, it was given to
the painter of a careful study of rushes on a river bank. No doubt
it was a faithful study, and the rushes were excellently painted,

* See chapter on "Grass ' (p 72).

P

but it was not a landscape, and all those who had painted landscapes were naturally surprised at the award Its supposed merit consisted in the most servile imitation of Nature, which excluded every particle of the personality of the painter, and only the abject ignorance of the *character* of things was revealed It will be interesting to follow the career of that young artist if he paints his landscapes in that spirit. He would have done better had he learnt more of the possibilities of the growth of his rushes, so that he could include them in any form when it was necessary.

Your picture may be said to be finished when it would be superfluous to add another touch to it, and when it rings in perfect harmony and rhythm of line and mass of tone and colour. The beauty and dignity of your composition, your scheme of colour, and all the personal and individual expression of your painting, should be full of that great quality which must be the dominant note of your picture, and that is the expression of the vital force and the convincing truth of Nature

I have already pointed out the advantage of making studies direct from Nature, as aids to painting How valuable, then, are studies of colour effects to those who paint their most important pictures in the studio, and who must, of necessity, depend upon them, and upon their recollection and impressions, for the truth they wish to convey

So much has been said in support of painting direct from Nature, and there are so many advantages accruing from the practice, that I should advise the student at present to confine himself to that particular method But it is nevertheless true, that some of the greatest landscapes in the world have not been painted on the spot; and it is also true that the artists who painted them only achieved success by passing through the curriculum and discipline I have attempted to describe I feel

sure that Turner would not have painted the pictures which stand highest in our esteem, had he not thoroughly acquainted himself with Nature by his constant practice of sketching For instance, we recognise his greatness in "The Shipwreck," or "Crossing the Brook," or "The Bay of Baiæ ' In the first picture the artist accurately reveals the power and majesty of the sea, and in the second and third, the wide outlook of the country lying in the vibrating light and heat of summer, conveying the most beautiful and subtle effects of broad daylight These were not, and could not, have been done on the spot Had they been so, they would not, in all probability, have expressed so much They were the result of profound and careful study, the outcome of a most powerful and receptive memory. His con-scientiousness is brought home to us more clearly when we examine the little annotated sketches in pencil of complex subjects, which he had drawn from Nature, and others which realised the most wonderful appreciation of beauty. He spared neither time nor trouble, but strove to express his ideal through the constant and persistent study which is indispensable to the landscape painter It is interesting to note that, in his artistic life, his develop-ment was based on the careful study of actualities. By the stages of materialism and realism, through which he passed, he earned the right to express the ideal He who will not serve is not fitted to rule, and never was there a case in any life in which this maxim was better verified. This service must be long and tedious for most; for others, less so, perhaps by reason of their innate capacity for grasping essentials. But is it not so in other departments of life? And if beginners could be saved from the inclination to stray from the path that leads to the goal, the goal would be sooner reached

Printed by
Cassell and Company, Limited,
La Belle Sauvage,
Ludgate Hill, London, E C

22 207

CPSIA information can be obtained
at www.ICGtesting.com
Printed in the USA
LVHW010714181222
735217LV00004B/435